BIDEFORD

THROUGH TIME

Peter Christie

& Graham Hobbs

AMBERLEY PUBLISHING

First published 2012

Amberley Publishing
The Hill, Stroud
Gloucestershire, GL5 4EP

www.amberley-books.com

Copyright © Peter Christie & Graham Hobbs, 2012

The right of Peter Christie & Graham Hobbs to be
identified as the Authors of this work has been
asserted in accordance with the Copyrights, Designs
and Patents Act 1988.

ISBN 978 1 4456 0910 2

British Library Cataloguing in Publication Data.
A catalogue record for this book is available from
the British Library.

Typeset in 9.5pt on 12pt Celeste.
Typesetting by Amberley Publishing.
Printed in the UK.

Introduction

It is odd how some books come to get written. Several years ago I was talking to Graham Hobbs in Bideford Pannier Market about my hope, one day, to compile a book of 'then' and 'now' photographs of the town. He offered to take the modern shots for the proposed book but the idea lapsed as we both became involved in other projects. Earlier this year, however, I was approached by Amberley Publishing wondering if I might be interested in producing a Bideford volume for their popular *Through Time* series. Contacting Graham he immediately said 'count me in' and here, in your hands, you have the joint product of our efforts. Having known the older photographs for so long I have been amazed how Graham's superb shots have breathed new life into them – and made me see the town in a different light. People often say that Bideford never changes much but these linked photographs show the sheer scale of the changes the town has seen through the last 150 years. We hope you enjoy the book as much as we enjoyed producing it.

We would like to add our personal thanks to those who have lent us their old pictures – with an especial thank you to Di Warmington for many of the old colour shots. Thank you.

Peter Christie & Graham Hobbs

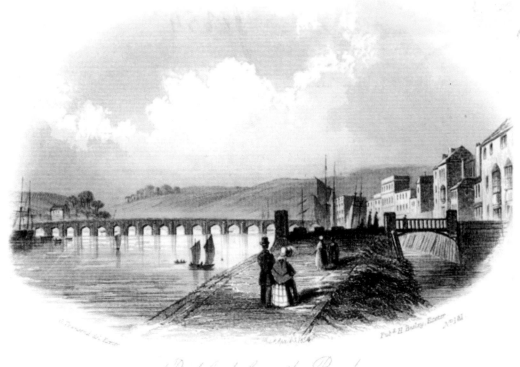

Bideford from the Bank.

An 1854 print of Bideford from the bank.

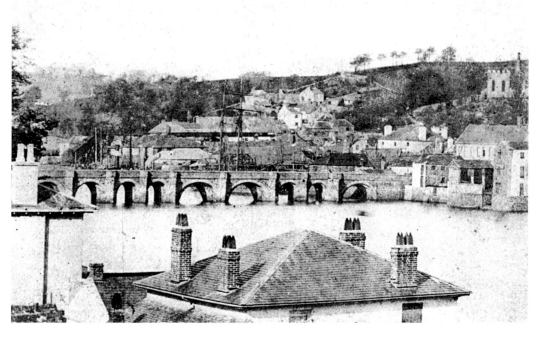

Bideford Bridge I

No-one knows when Bideford Bridge was built though possible dates range from the 1280s to 1340s. Needless to say, this medieval structure is one of the glories of the town. Photographs of the bridge prior to its widening in 1866 showing its original shape are rare and this is probably the best to survive. The twenty-four arches of different widths are seen clearly, almost certainly reflecting the size of timber available to the original builders, as the first bridge was a wooden one.

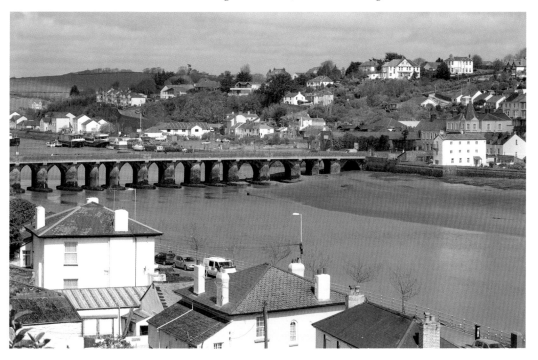

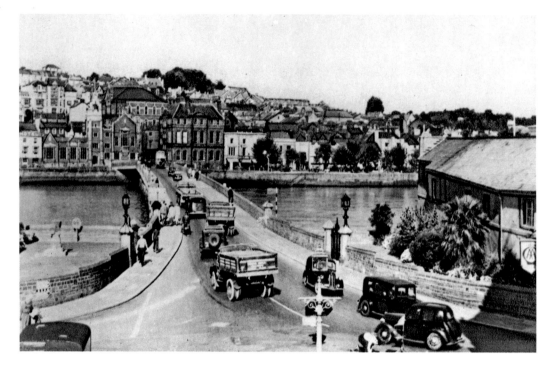

Bideford Bridge II

Taken from the railway station this would have been the first view many people would have had as they arrived in town. In this 1950s shot, traffic is just as heavy as in the 2012 version, highlighting the importance of the bridge to the town and to the local transport network. It also shows what a glorious setting Bideford has and how lucky its inhabitants are to live here.

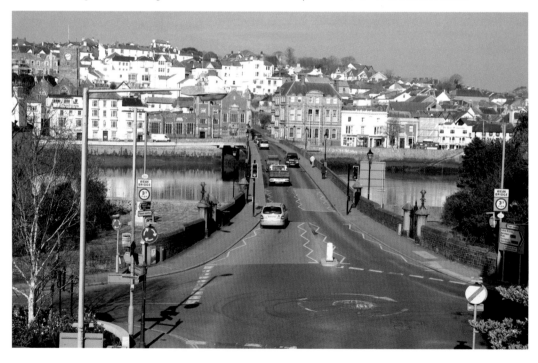

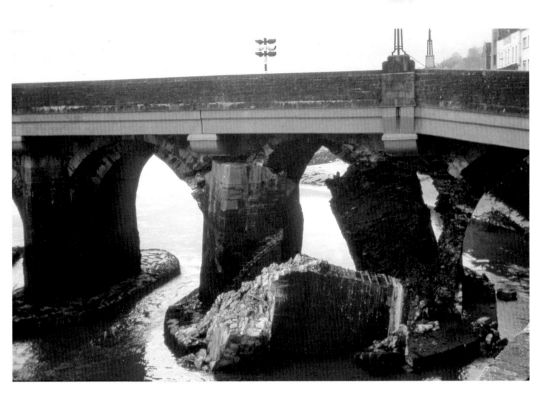

Bideford Bridge III

On 9 January 1968, the two westernmost arches of Bideford Bridge collapsed, probably due to a combination of traffic vibrations and ice damage. Described as 'the greatest local calamity since the plague in 1646', rebuilding took many months with care of the structure passing from the Bridge Trust to the Ministry of Transport. The scene of ruin that met onlookers on the morning after is shown here – and what it looks like today forty-four years later.

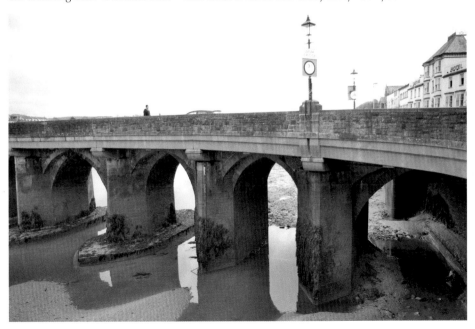

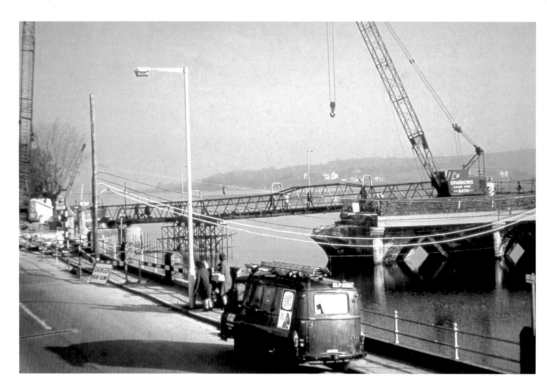

Bideford Bridge IV
Whilst reconstruction was going on a footbridge was put in place as shown in the first photograph. Since then resurfacing and strengthening of the medieval bride has continued with the most recent work only being completed earlier this year (2012). The 1987 high level Torridge Bridge is seen in the background.

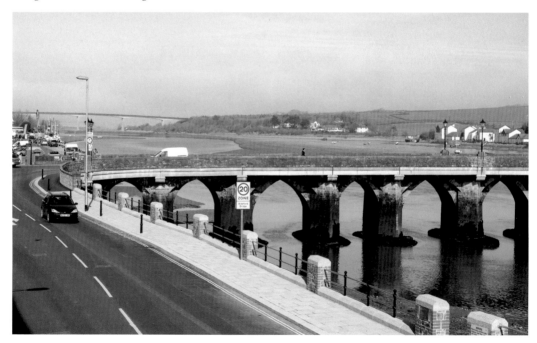

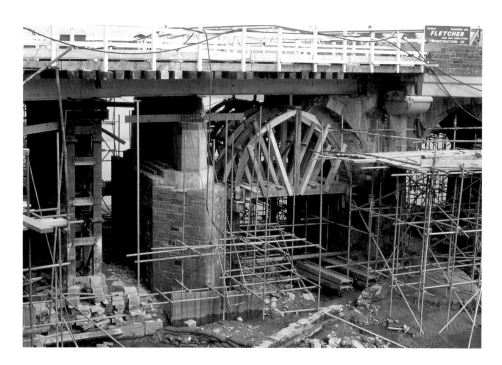

Bideford Bridge V

Over the next year rebuilding of the two arches took place with specially made wooden templates being constructed to allow the new arches to be matched to those that had collapsed. The templates are clearly seen here, as is the mass of scaffolding that was erected around the area and the temporary wooden surface erected over the gap. Our second shot shows a very placid looking scene with the concrete buttresses erected in the 1925 rebuilding to carry the walkways clearly seen.

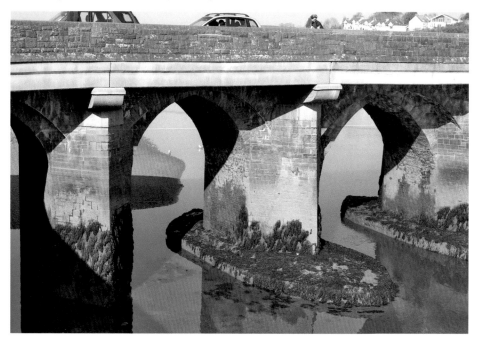

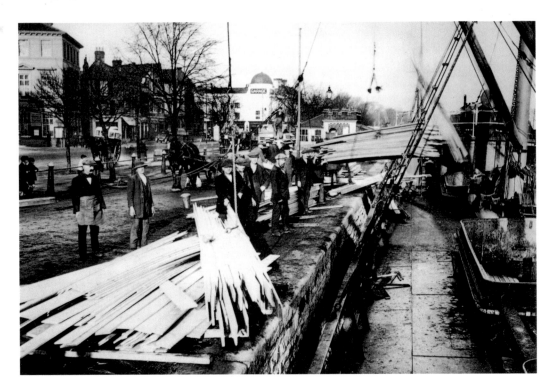

Trading Vessels

Bideford no longer gets cargoes of tobacco from North America or fish from Newfoundland, but we do still have the unusual sight of ocean going vessels loading and unloading freight right in the centre of the town, as shown in these two photographs taken a century apart. The modern one was actually taken from the bridge of the *Vasily Shukshin*, a Russian vessel loading clay in 2012 – a major export through Bideford.

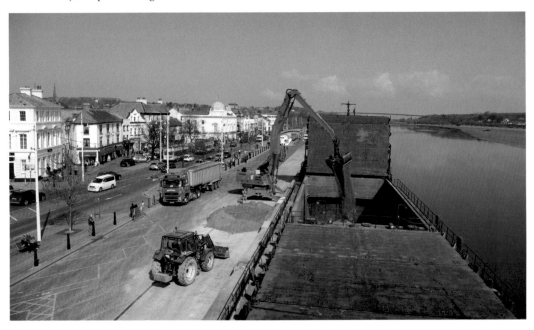

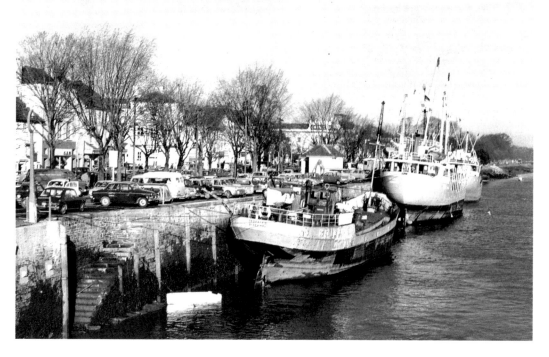

The Quay I

Today the port is looking for new cargoes to keep it profitable and busy. The two photographs reproduced here are also about forty years apart – yet the number of cars parked on the quay does not seem to have changed much even if their designs have. The old trees in the first shot were replaced a few years ago by new ones when the entire quayside was extended 18 feet and a new parapet put in place.

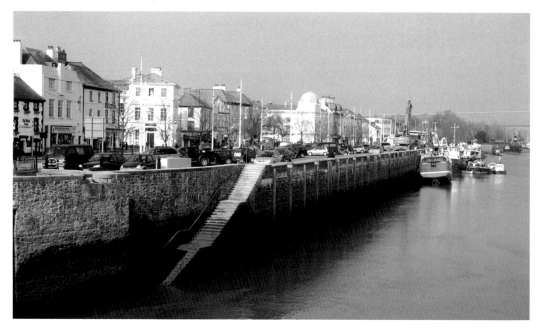

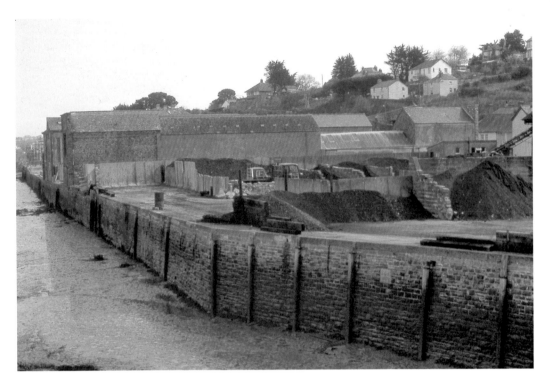

The Quay II

The quay provided the main harbour facilities in Bideford, but those at East-the-Water were also important. Seen here around 1970 they were notable for their large coal stores and warehouses. In October 1972 most of these old buildings were demolished. The only structures to appear in both photographs are the two small buildings to the centre-right; the rest are now empty awaiting redevelopment.

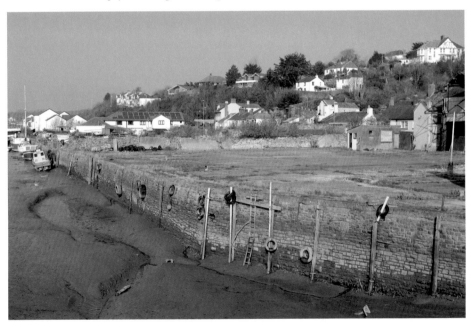

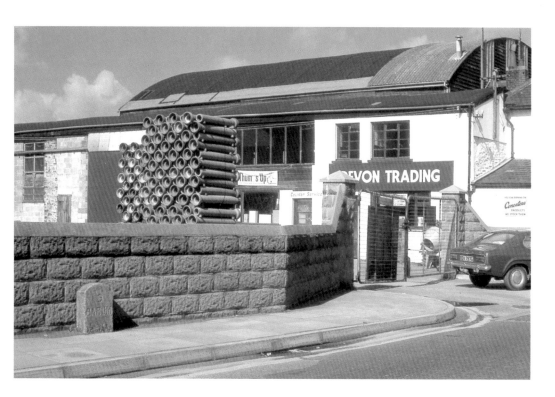

Builder's Merchants

All things change and perhaps not always for the better. The first photograph from around 1970 shows the premises of 'Devon Trading', a builder's merchant that once occupied a great swathe of the wharves at East-the-Water. Sited here to unload material directly from small coasting vessels, it closed and its buildings were cleared with the area becoming tarmacked by Torridge District Council to provide a car park. As this is being written the site is currently up for sale by the council.

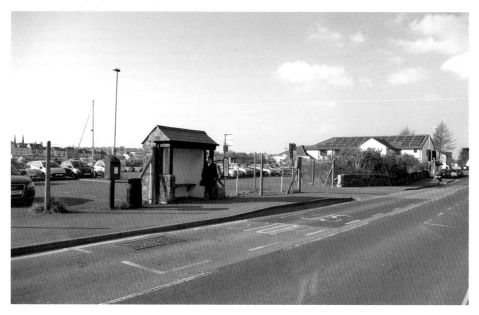

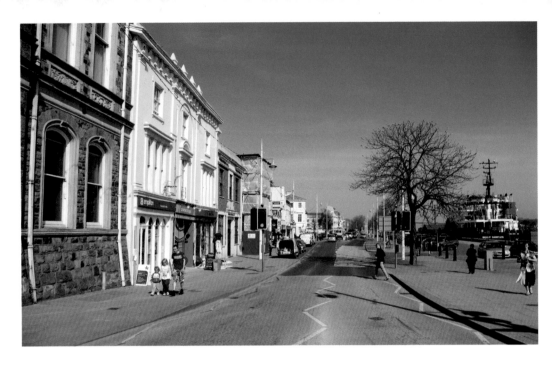

The Quay III

This photograph is one of the earliest in the book, dating I think to pre-March 1857. The narrowness of the quay might surprise modern visitors, who would see the scene in the second photograph. Quite a few of the buildings are still recognisable today and the plastic cladding to the one in the centre indicates that change is still continuing. When the trees were planted in the 1890s many complained that their presence would destroy the port business.

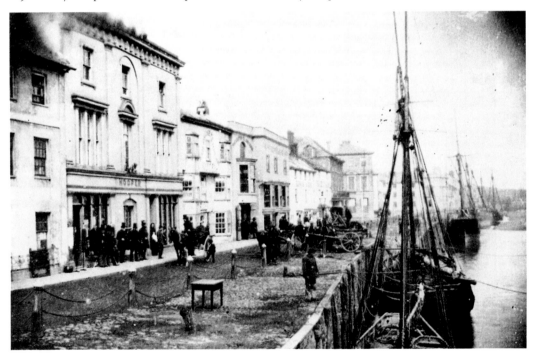

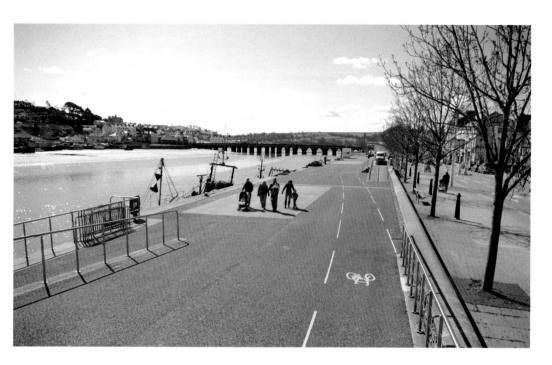

The Quay IV

The quay around 1895 with freshly planted trees and no railway lines yet laid. The 2012 photograph shows again just how wide the quay is, although 18 feet of extra quay has been added since the earlier shot. The old trees were replaced several years ago but the boats and the bridge are still there, enduring features of Bideford and long may they remain.

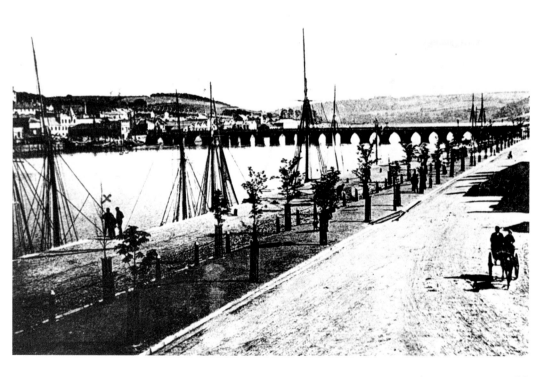

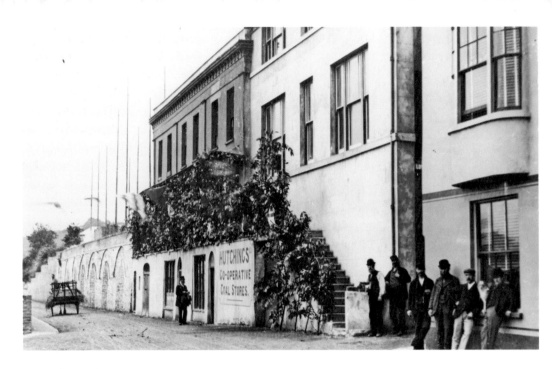

Tanton's Hotel

Tanton's Hotel in New Road was a very busy place, so much so that it had to extend into buildings next door. The first floor bay window of the hotel is seen on the right of this 1896/97 photograph – dateable by the scaffolding poles over the old coal cellars erected to facilitate construction of today's police station. The coal cellars have been bricked up but the railings along the walkway still remain. Currently Tanton's is not open due to an arson attack but all Bidefordians hope it will resume business sometime soon.

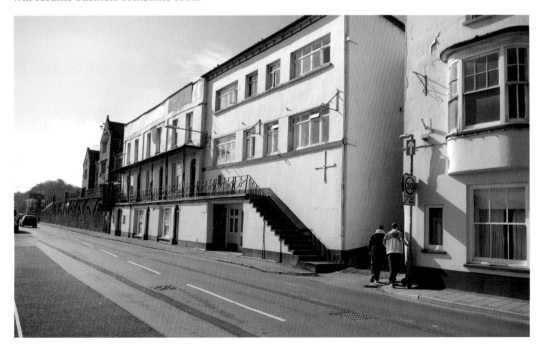

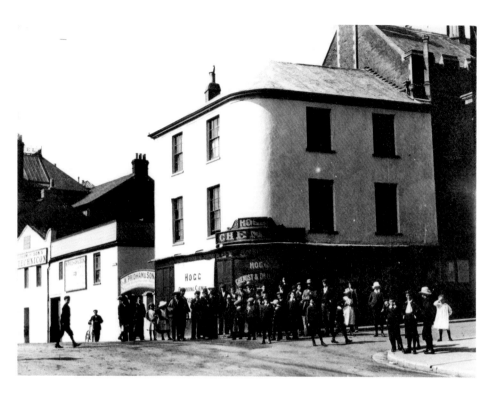

Hogg's Corner

Locally known as Hogg's Corner after the chemist's shop that was here for much of the nineteenth century this has been greatly changed. For many years the town council wanted to expand the Town Hall (built 1850–51) and in 1906 they finally completed the new extension plus a new library, both of which are seen in the second photograph which also shows detachments of local youth organisations marching past on a civic occasion in 2010.

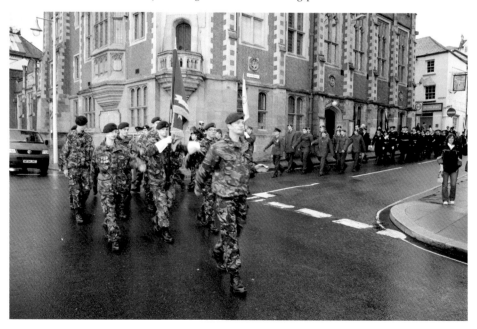

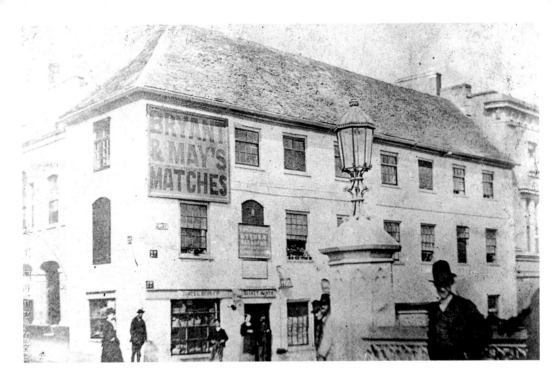

Bridge Buildings

The photograph above dates from sometime before 1882 when the Bridge Buildings were built by the Bridge Trust. The building to the left in the older photograph was the Town Hall/Grammar School whilst the building to the right is still recognisable today. The very ornate gas lamp has long gone but the stubby pillar it stood on is still present, just behind the lady in the striped top. The massive Bridge Buildings were sold for a purely nominal sum to Torridge District Council.

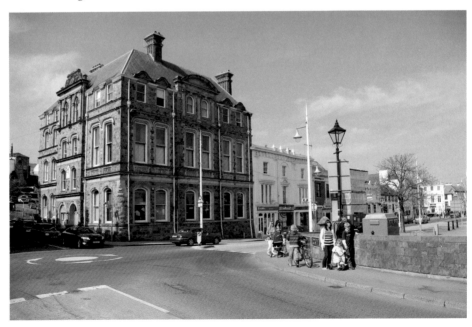

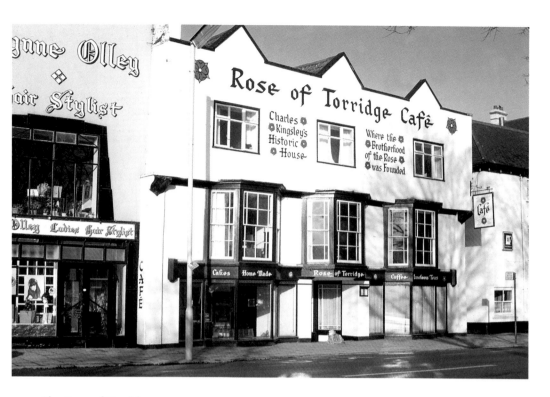

The Rose of Torridge

The Rose of Torridge is named after a character in Charles Kingsley's *Westward Ho!* Built in 1626, the building has been much changed but is still easily identified today. In the 1970s photograph it was being used as a much missed café whilst to the left was Wynne Olley's hairdressing salon. Today, the building houses 'Mr Chips' restaurant whilst the old salon is undergoing a badly-needed rebuild.

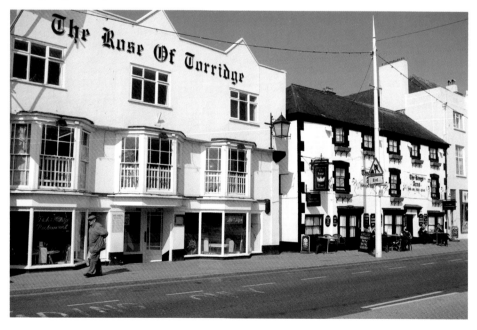

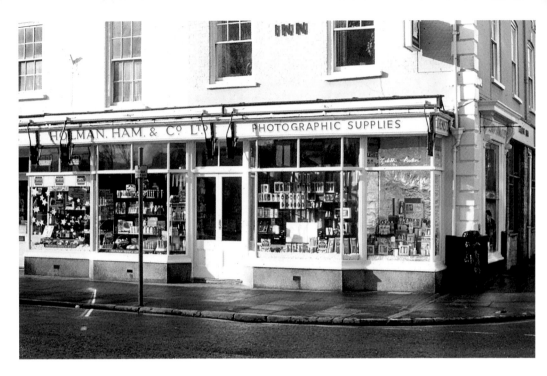

Corner of High Street and the Quay

During the latter half of the nineteenth and most of the twentieth century the corner of High Street and the quay housed a chemist's shop. The 1960s photograph shows the crowded windows of Holman, Ham & Co., which has given way to a 'Chic-o-land' fast food outlet. Note the odd looking stone at the right – possibly the 'tome stone' referred to in sixteenth-century documents where Bideford merchants sealed deals by putting cash on the top of the stone.

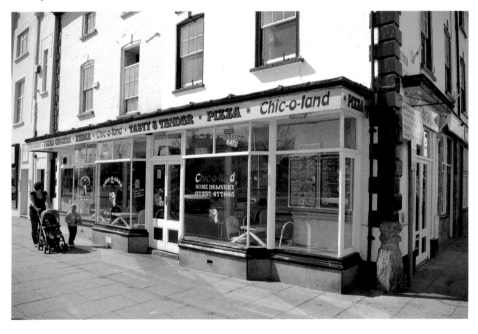

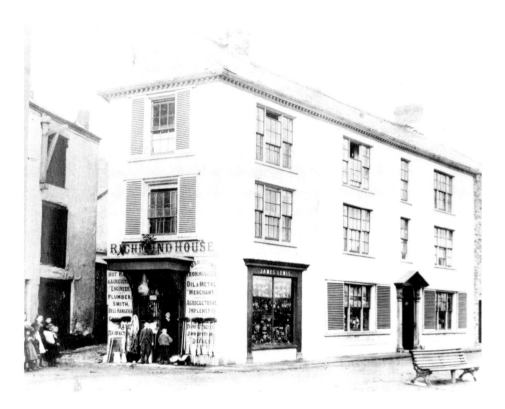

The Quay V

These pictures show the large building on the quay with King Street behind. Back in 1900 when the first was taken, James Lewis was running a well-stocked hardware store in the small shop at the end. In the 2012 photograph Radford's news agency is now in this shop with a cake shop and a florist's being found on either side of the still ornate door.

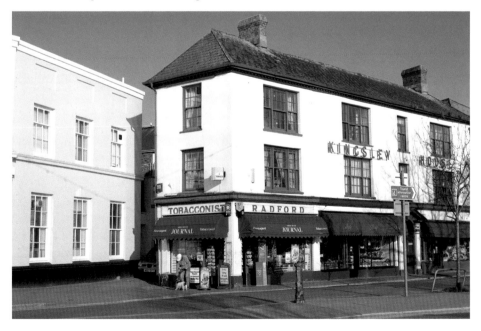

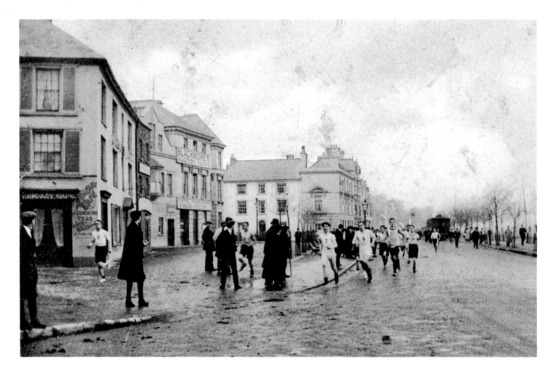

Athletic Race

The first shot dates from around 1910 and shows an athletic race along the quay. In the background on the right can be seen one of the engines of the Bideford, Westward Ho! & Appledore Railway. The same scene today is shown in the second shot with the shop on the left in both. The green copper dome on top of Heard's old garage is seen in the middle with modern cars taking the place of the long disappeared train.

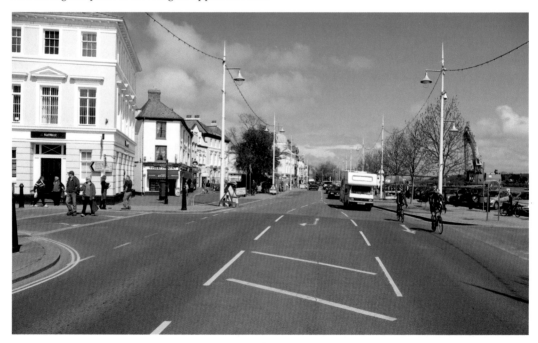

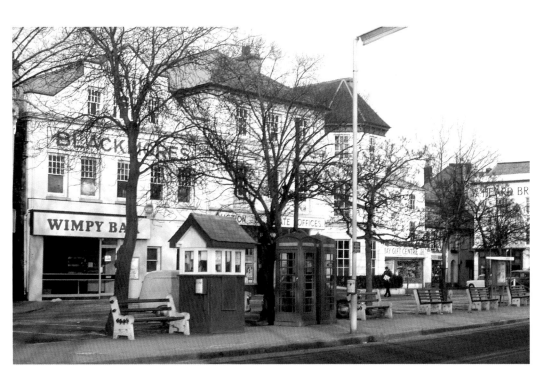

Jubilee Square and the Manor Car Park

The first shot dates from the early 1970s and shows a very different range of street furniture to that seen in the 2012 photograph. The old telephone boxes, seats and lamppost have gone to be replaced with a stainless steel rubbish bin, a bus stop and a modern lamppost. Another thing that has disappeared is the 'light up' map on the extreme right that used to delight children who loved to push its buttons.

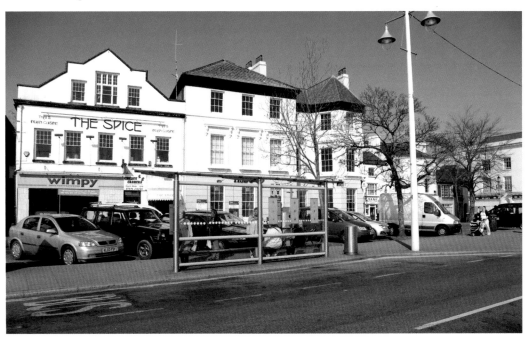

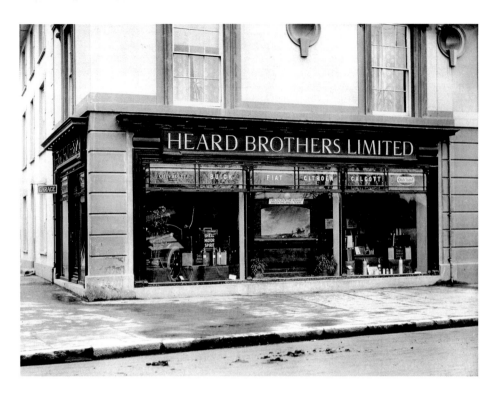

Jubilee Square

The building on the corner of Jubilee Square was a grand garage/motor accessories shop for many years. The first photograph possibly from the early 1920s shows the garage as it used to be with a large car showroom with signs in the window advertising Chevrolet, Buick, Fiat, Citroen, Calcott and Oakland cars. Today, the garage has gone and a modern convenience shop occupies most of the premises with a Chinese takeaway next door.

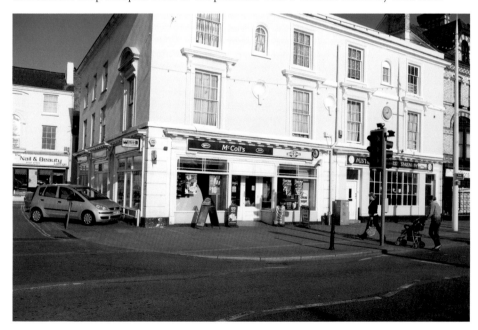

The Quay VI

These houses on the quay were built by Mr J. Cock, a well-known local builder and Mayor of Bideford 1905–06. His use of different coloured bricks to provide decorative bands on the two buildings is well done and still remains very attractive. The 'then' photograph dates from the early 1970s whilst the 'now' one shows a local solicitor/estate agency and a branch of a multinational.

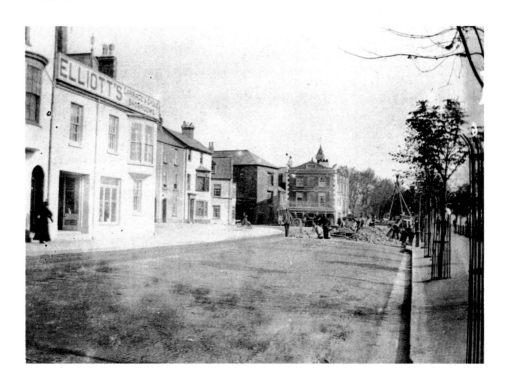

The Quay VII

The openness of the quay area is well displayed in these photographs – the result of many extensions over the centuries. In the first photograph from around 1900 we see a very different series of buildings to the 2012 photograph. The large Manor House is still present whilst the BARC clubhouse is being used as a warehouse and today's Nationwide has yet to replace Elliott's Carriage & Cycle Showrooms. The workmen are laying the rails for the Bideford–Westward Ho! railway (the Appledore extension came later) illegally.

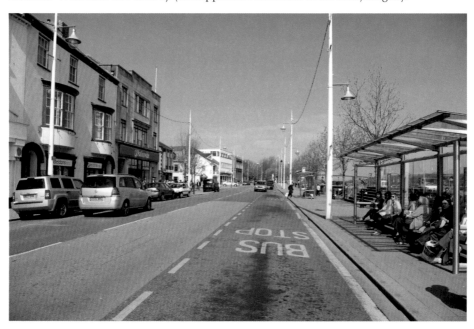

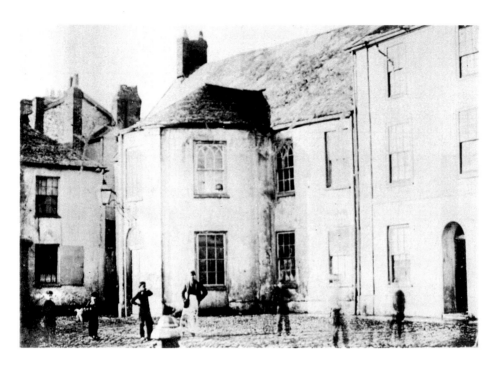

Grenville House

This fascinating photograph possibly dates from around 1870 and shows the original Grenville House on the quay when it was known as the Assembly Rooms and provided a venue for plays and balls. The structure was later extensively remodelled and today provides premises for a local firm of solicitors as shown in the 2012 shot. The 'ghostly' nature of several of the people shown probably reflects the slowness of early cameras.

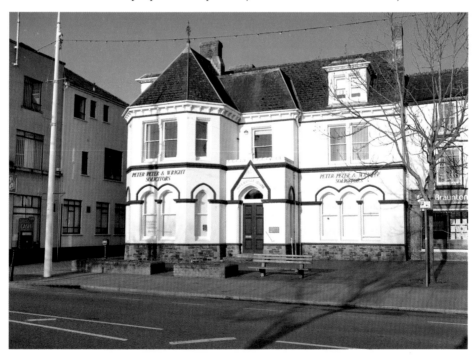

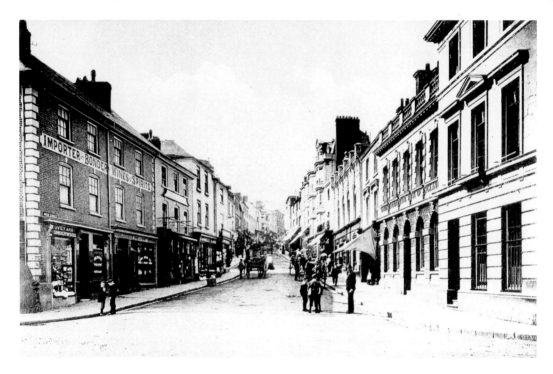

High Street I

The bottom of High Street pictured around 1900. The street is at its widest at this point and was probably the site of the earliest market. Indeed, there is a record that the market moved from here in the seventeenth century. The buildings are still recognisable today, even if the shop fronts and their contents have greatly changed. Oh and one other thing, High Street is very steep hence this modern photograph which shows what can happen when ice and snow blanket the town.

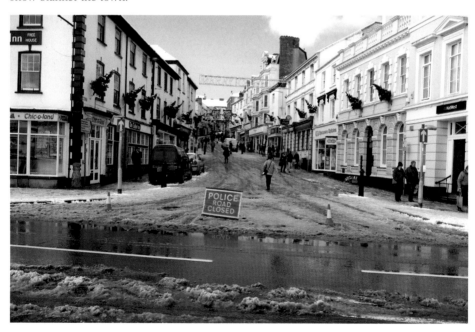

Dawe & Son

Dawe & Son were a local grocery business which built a large shop on the corner of High and Mill Street before selling part of the building to a bank. The latter (which became Barclays) took over the rest of the building and did away with the large shop windows and double-door entrance. Note the highly ornate bank entrance in the modern photograph – redolent of the days when financial institutions were seen as solid and trustworthy! The older shot is thought to date from the 1920s.

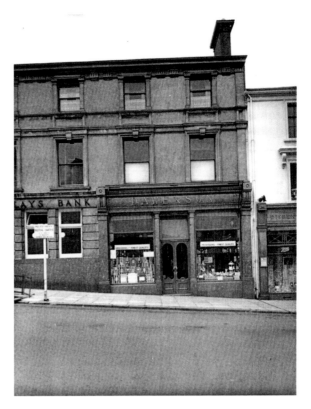

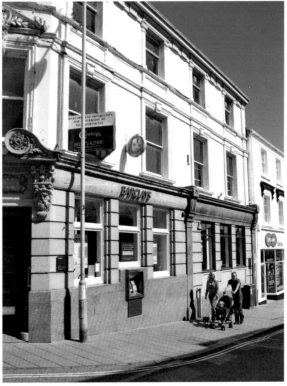

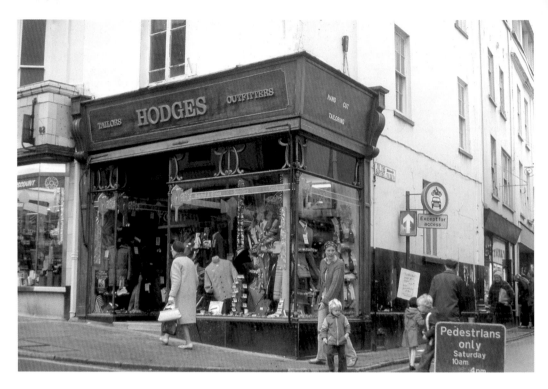

Junction of Mill and High Street

The junction of Bideford's two main shopping thoroughfares, Mill and High Street, around 1980 and some 30 years later. This is perhaps the busiest corner in town which makes it odd that so many different shops have come and gone over the years – even the one shown in our March 2012 photograph has now gone! The corner of the old Curry's shop is glimpsed to the left in the older photograph, another store that has left our High Street and gone to out-of-town megastores.

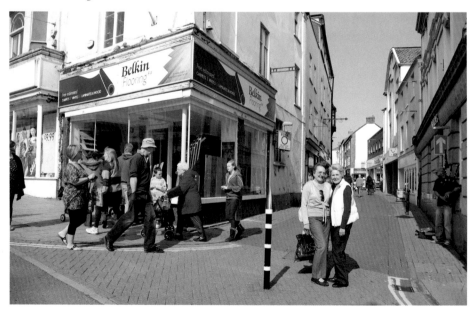

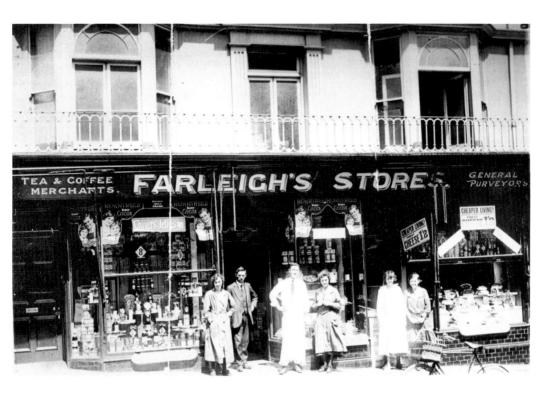

Farleigh's Grocery Shop

Only by looking at the windows above the shop fronts will you recognise the same building in these two pictures. The 1920s shop front of Farleigh's grocery shop is shown with its proud staff standing in front, whilst the 2012 photograph reveals a much altered frontage. The clothing of the young mother is in distinct contrast to that worn by the female staff in the earlier shot. One wonders what a similar shot seventy-five years from now might show.

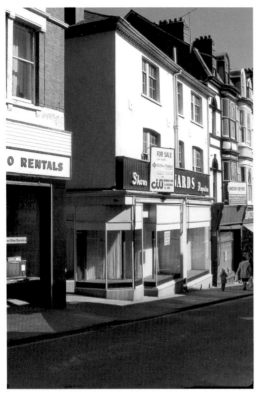

Where New Street joins High Street

The presence of shadows in both photographs demonstrates the narrowness of the road at this point. The first photograph dates from the early 1970s and shows a Radio Rentals shop on the left, taken in the days when televisions were so expensive that many people rented a set rather than buy. The two empty shops next down are a reminder that shops often come and go. One does have to wonder at the keenness of the yellow line painters shown here!

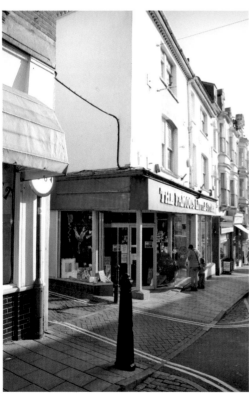

Small Businesses

Bideford is lucky in that it still has many small businesses. Many may be struggling to survive but they are still here, often in buildings with wonderful frontages as here. These two High Street shops are pictured in the early 1970s and again in 2012. In the earlier shot Stephen's toyshop and Truscott's jewellery shop are in place. In the new photograph Walter Henry's bookshop and Thomas Cook travel agency are present, the former still utilising the beautiful curved Edwardian windows.

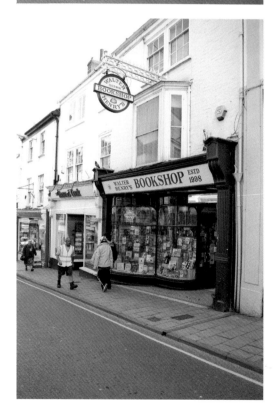

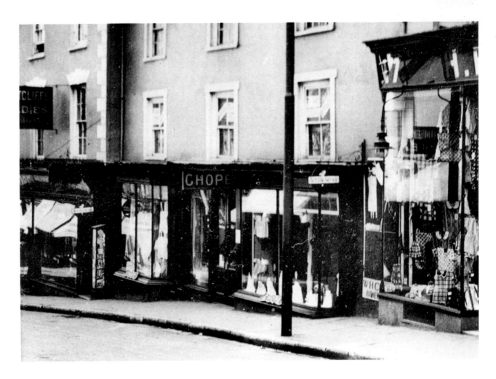

The Chope Family

The Chope family have long been associated with Bideford, most famously as drapers in the High Street. Their large premises dominated the area for many years with the shop frontage being regularly updated to reflect new fashions in architecture. The first photograph shows the shop in the 1920s, whilst the second shows what the building looks like today. The family still run Walter Henry's bookshop next door and a drapery shop at the rear of Bridge Street car park.

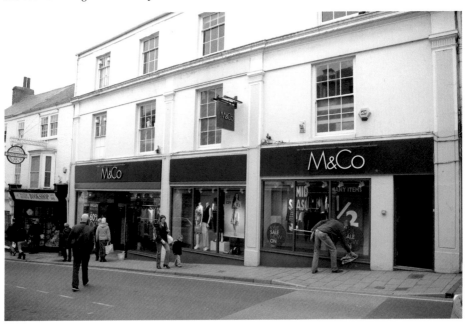

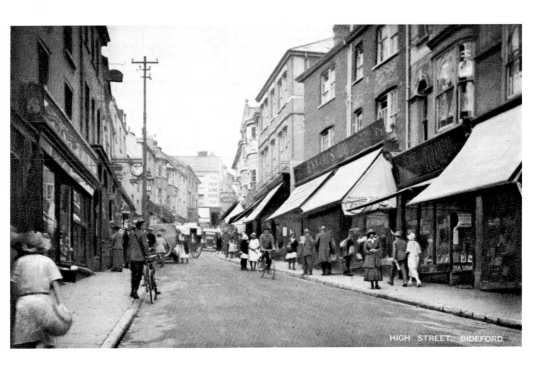

The High Street II

The High Street in the 1920s was packed with shops, all with their sun blinds down to protect the stock from the sun's rays. Roughly the same view from 2012 shows just one such blind, yet the shops and shoppers are still there and now the street is one way – up – though it is still as steep as ever.

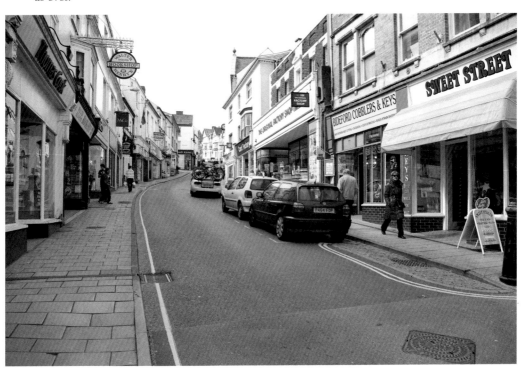

The High Street III

This High Street site was provided by the Bridge Trust for a new post office in 1886. There was a large yard behind but the site became ever more difficult to access and the office eventually closed and moved to the quay. The shop became a supermarket as shown in this 1970s photograph and then a charity shop before being refurbished by the Bridge Trust in the 1980s for a branch of the Lloyds TSB. When this closed, Ladbrokes moved in. The magnificently restored front is still an eye-catching feature of the High Street.

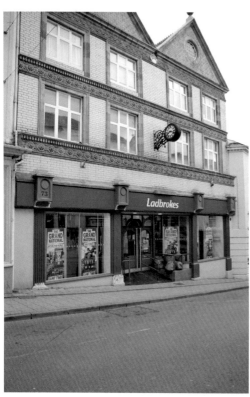

The High Street IV

This greengrocery shop in High Street burnt down in the early 1970s and was totally gutted. After a few years of lying derelict the site was redeveloped for a branch of the Halifax as seen in our second photograph. The county council's 'listings' officer visited Bideford some time after and the builders had done their job so well that he was fooled into thinking this was a genuine old building, and 'listed' it, making it probably the most modern 'listed' building in Britain!

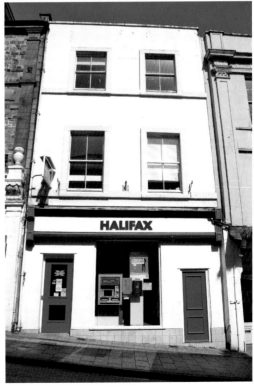

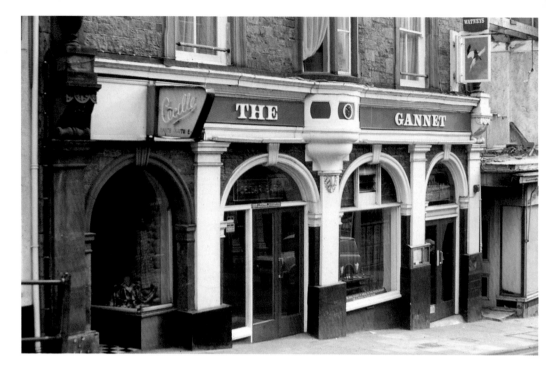

The High Street V

One of the grander buildings in the High Street is shown in this photograph. When the Gannet public house was reconstructed in the nineteenth century the builders suffered a rather embarrassing disaster when the entire front wall collapsed one night. The pub used to contain some wonderful old wine vaults but these were torn out in the 1980s though a deep well in the basement still survives along with a story that gold Roman coins wrapped in a lead sheet were found at the bottom when it was drained!

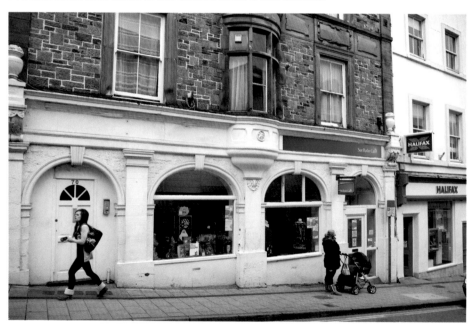

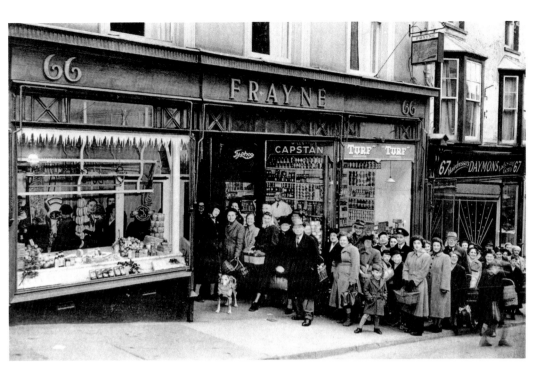

The High Street VI

As supermarkets have grown smaller shops have disappeared and the street scene has changed. These two photographs exemplify this movement; the first from around 1948 shows a large queue of mainly female shoppers waiting to get into Frayne's grocery/butcher shop. The shop later went through many incarnations, including a second-hand record/bookshop. I ran in the one on the right in the 1980s, before it became completely refurbished into flats.

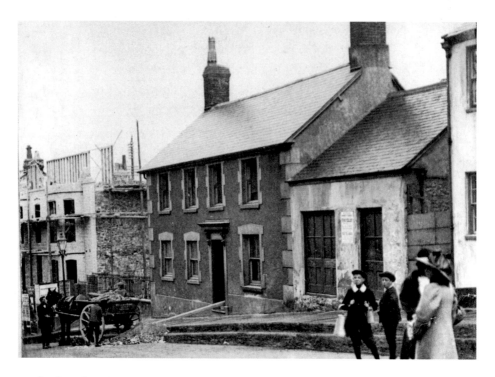

Methodist Chapel

The astonishingly grand Methodist Chapel in High Street dates from 1913 and here we see the site prior to its construction. The houses to the left, still extant today, are under construction whilst the corner of the house to the right is the same in both shots. The curious double step pavement curb has been filled in to provide a sloping edge in the 2012 photograph. The contrast in clothing between the Edwardian and early twenty-first century children is striking – Eton collars and caps replaced by T-shirts and trainers!

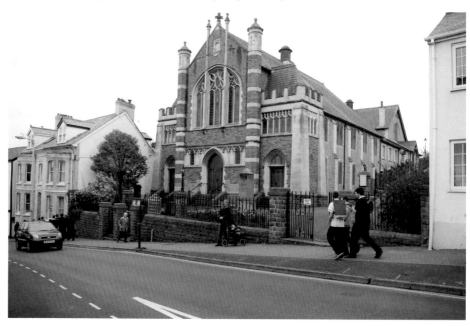

The High Street VII

Watson's news agency still exists in High Street but here was an earlier incarnation from the early 1980s in Mill Street, with the usual rotating postcard stand and racks of paperbacks just visible. The windows may have changed in the 2012 photograph of the WHSmith store that is now in the shop, but the old public thermometer, advertising Stephen's Inks, is still in place with its very optimistic top reading of 140 degrees Fahrenheit!

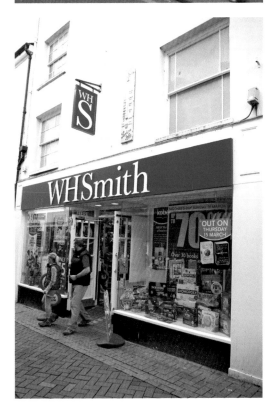

Mill Street I

Here can be seen the centre of Mill Street opposite the Baptist church with the very popular butcher's shop of Terry Derrigan in the middle in this 1980s photograph. Prominent on top of the old Nicklin's building is the 'Ragged Newsboy', erected by Thomas Tedrake, editor of the *Western Express* newspaper. The much loved statuette was unfortunately destroyed by a drunken lout several years ago but the townspeople rallied together, raised a subscription list and John Butler, the noted local woodcarver, created the replacement seen in the second photograph.

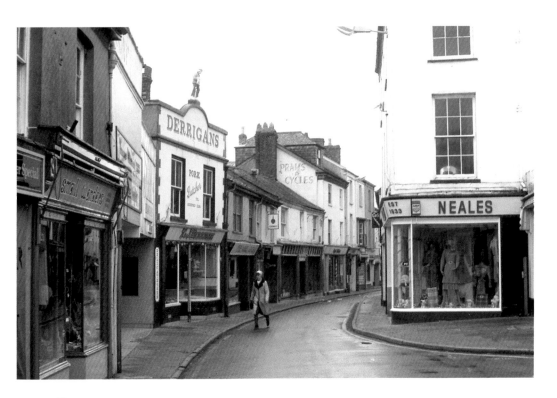

Mill Street II

Another view of Mill Street from the other direction taken in the 1970s. The very narrow and sinuous nature of the road comes over well here. In the second photograph two of the shops are empty, both having been vacated just before we obtained this shot – but given Bideford's resilience we are sure they will soon re-open. Note how the old kerbs and pavements have gone, to be replaced with varicoloured brickwork.

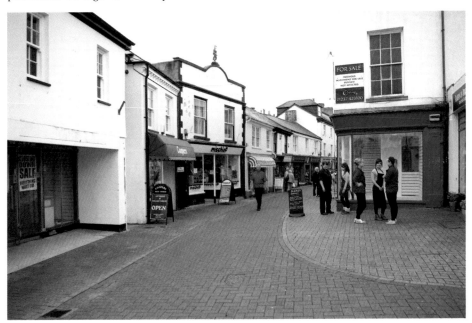

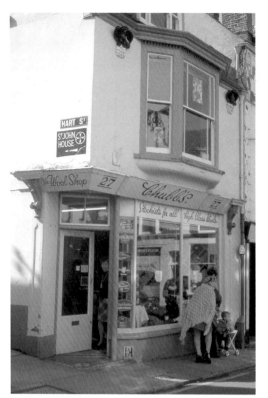

Hart Street

This tiny shop stands at the entrance to Hart Street. In the early 1970s shot it housed Chubb's wool shop, with the lady outside wearing a knitted poncho. By 2012 it had become a takeaway pizza shop – an interesting alteration reflecting changes in society as much as anything else! Note in both photographs the two 'eagles' mounted on the wall just below the roof. They possibly originated at Annery pottery in Weare Giffard, whose stock was purchased by I. Baker and brought to Bideford for sale.

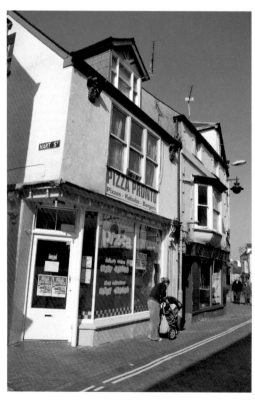

Mill Street III

Part of Mill Street around 1900 and again in 2012, but the picture is puzzling once you begin to look in detail. The antique shop in the centre of the modern shot is three storeys – so is it the three-storey building in the earlier one? And if so was the two-storey one in the middle demolished to extend what used to be Webb's furniture store to the left? Perhaps the two-storey one in the 1900 photograph had an extra storey added? Some detailed research is called for!

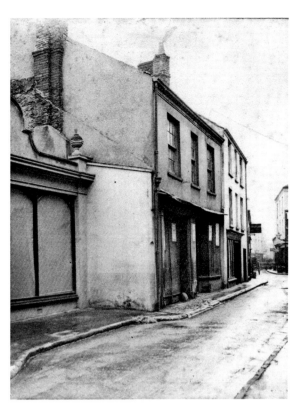

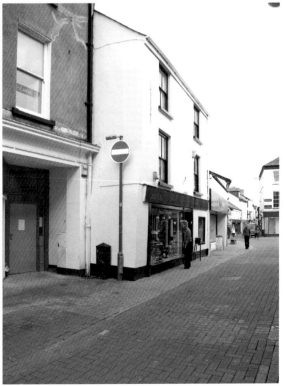

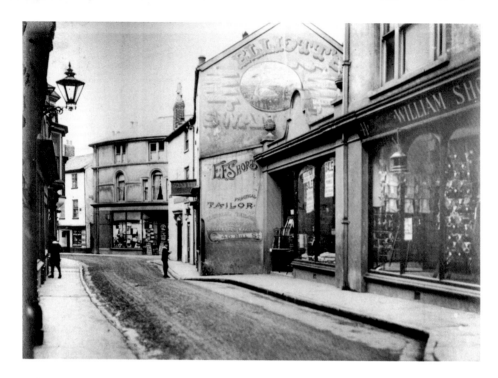

Mill Street IV

The end of Mill Street where it meets Bridgeland Street. The curved building at the junction is still recognisable today but everything else has changed. The extravagant wall painting for the Swan public house has gone and all the buildings to the right have been rebuilt as has the one next to the building with the curved frontage. What would we give to still have the ornate gas lamp on the left? A colourful florist's business now occupies the shop at the end.

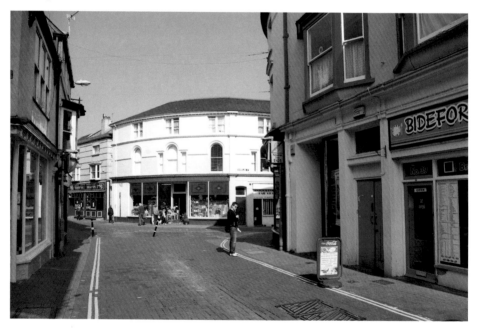

Swan Public House

The tiny Swan public house in Mill Street is shown in this early 1970s photograph. Such small pubs were the first to go as public drinking habits changed, and Bideford, once known as the 'Pack of Cards' for its fifty-two licensed premises, has seen a massive shrinkage in such places. Today, the Bideford Café occupies the site with new windows. The beautiful curved glass front to the tiny shop to the left is still there though Derek's Hairdressing Salon has long gone.

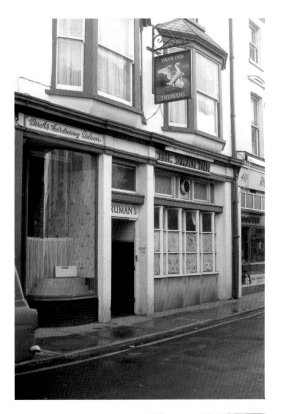

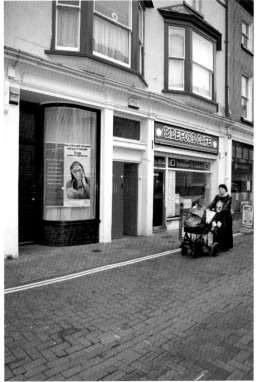

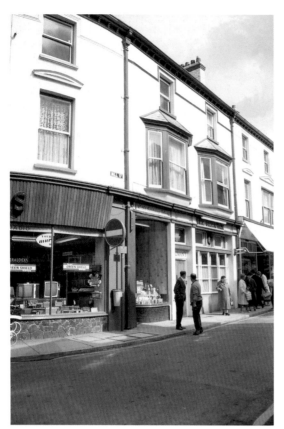

Mill Street V

This is just around the corner from the last photographs and shows the northern end of Mill Street. The first photograph dates from the early 1970s and shows the Swan Inn just behind the two men chatting on the pavement. Braddick's shop on the corner displays signs saying they give Green Shield stamps on purchases – a wildly successful but short-lived marketing wheeze. The second photograph shows the Bideford town band pictured as they rounded the corner from Bridgeland Street in 2010.

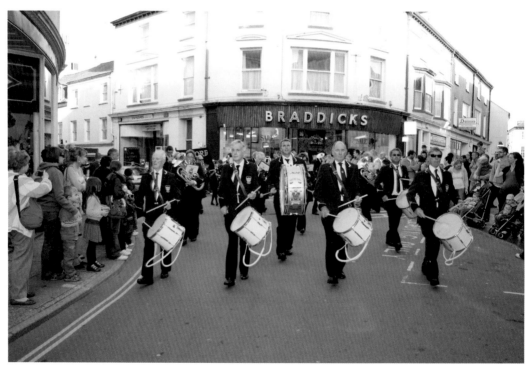

Mill Street VI

The building next door was purpose built as a coach builder's workshop as shown in this photograph from around 1910. The confidence of the owner comes over well and one can only admire the skill displayed in the brick detailing apparent on the frontage. The modern photograph shows new windows with some but not all of the brick details picked out in red paint. Note that the earlier photograph features one of those ornate gas lamps apparent in other shots from around this date.

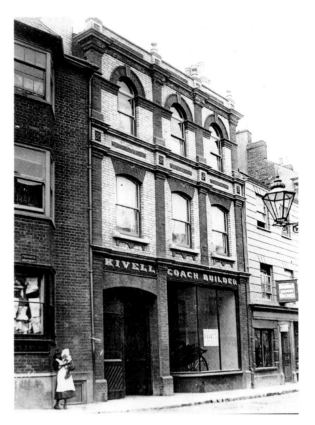

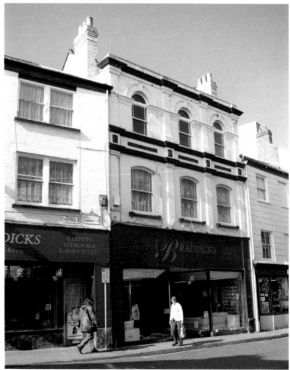

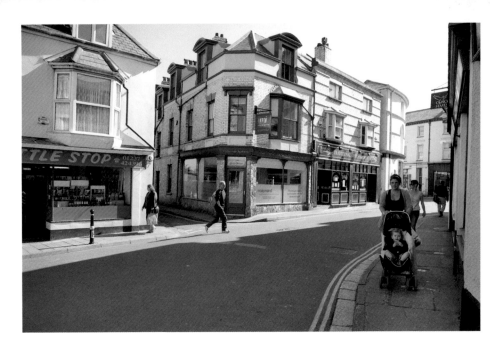

Entrance to Willet Street

It is only the presence of the twin spires of Lavington glimpsed over the roofs in this *c.* 1900 photograph which really identifies this shot. The entrance to Willet Street is in the centre and this is still here over a century later in our second shot. In the intervening years all the shops either side of Willet Street have been totally rebuilt to house an off-licence, accountancy firm and a fish and chip shop – one of the more dramatic changes in the town perhaps?

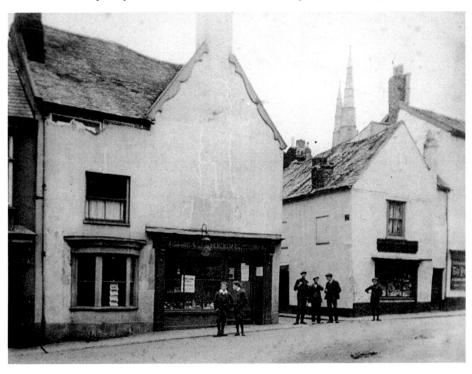

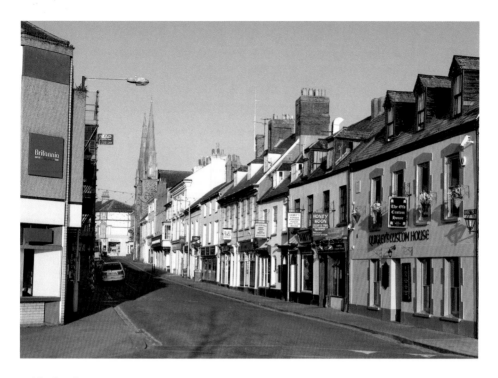

Bridgeland Street I

Bridgeland Street owes its existence (and grandeur) to the Bridge Trust who, around 1690, began to develop a jumble of old houses, sheds and riverside yards into a new street. The first was built in 1692. Daniel Defoe visited around 1704 remarking it was 'broad as the High Street of Exeter, well-built, and which is more than all, well inhabited, with considerable and wealthy merchants, who trade to most parts of the trading world'. The first shot is from around 1910 whilst the second shows little change.

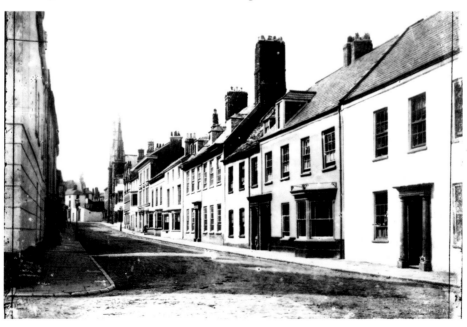

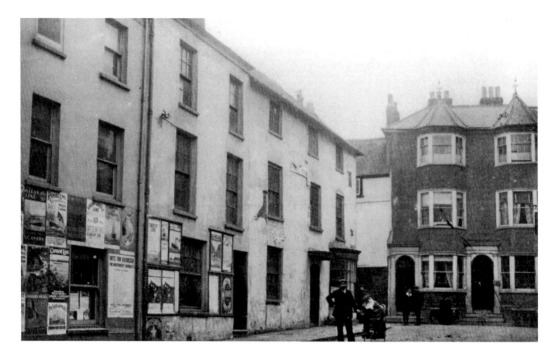

Bridgeland Street II

It takes a little while to recognise where this *c.* 1900 photograph was taken although if you focus on Braddick's furniture shop at the top right you should be able to place it from the chimneys and roof line if nothing else. The top of Bridgeland Street had a very narrow and sharp turning into Mill Street and when it was rebuilt the opportunity was taken to round off the ninety degree bend into a wider access.

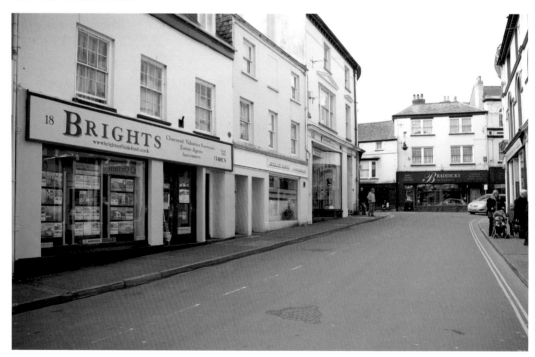

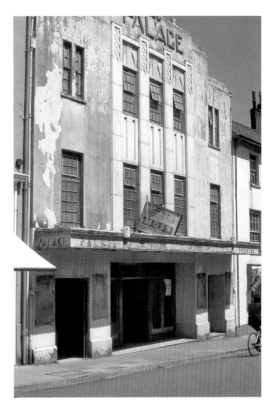

Bridgeland Street III

Bideford has had five cinemas although only one remains. This photograph shows the Palace cinema in Bridgeland Street, which thrived for many years before being killed off by the new-fangled television. The building was demolished and replaced by a 1960s 'brutalist' supermarket run under the name of Ford & Lock, which in turn became the Bideford Carpet & Furnishing Centre, though recent plans will see it become a Weatherspoon's public house.

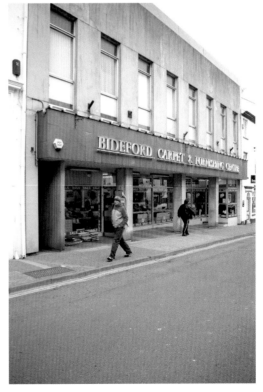

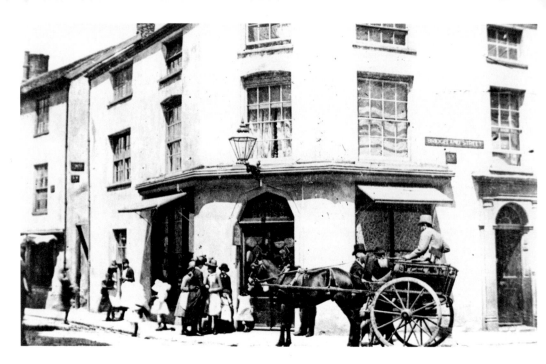

Bridgeland Street IV

This corner where Bridgeland Street meets Mill Street has changed out of all recognition. In the early 1890s shot we see an angular building with a massive gas lamp and beyond it an old shoe shop. In the 2012 photograph the corner has been entirely rebuilt to form a graceful curve and the shoe shop has been demolished and replaced with a modern fish and chip shop.

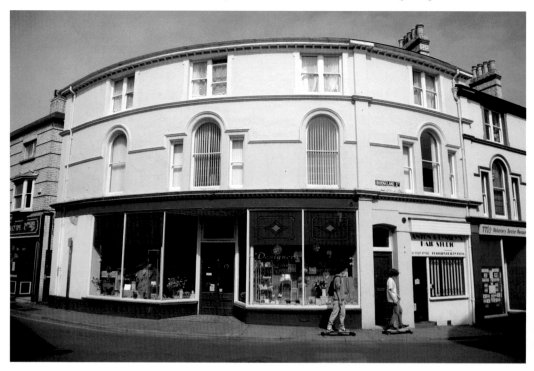

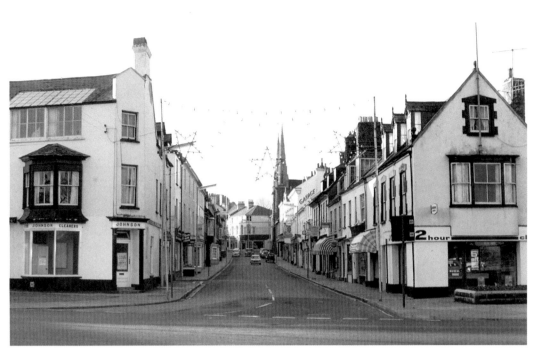

Bridgeland Street V

Given its width it is hardly surprising that Bridgeland Street has often hosted public events with the town carnival always drawing crowds at this particular point. This late 1960s photograph shows some sketchy Christmas decorative lights as well as the old building on the corner on the left. Our second photograph shows part of the 2011 carnival procession with local entertainer 'Merlin'. One wonders what the Bridge Trustees of the 1690s would have made of such a sight in their 'new' road.

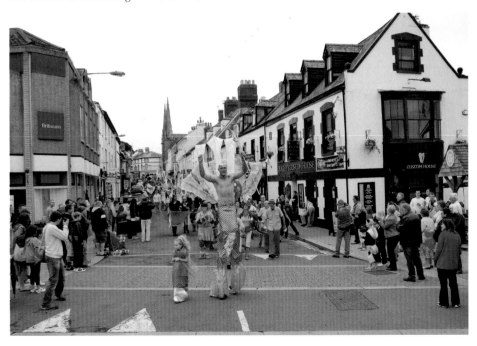

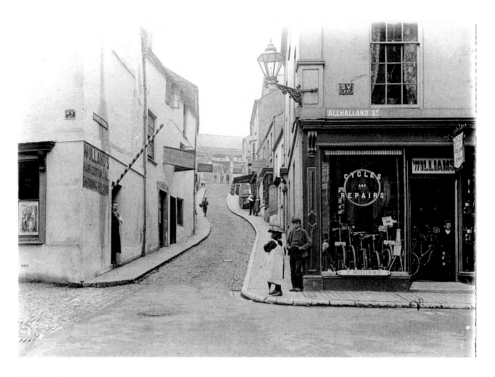

Bridge Street

Our first photograph dates from around 1895 and shows the bottom of Bridge Street. The cycle shop was demolished to make an entrance to the Bridge Street car park. Note Wolland's barber's shop with its old-fashioned striped pole. The modern photograph shows the Bideford Pipe Band with a much altered backdrop. The shops have gone and the hairdresser's is now an empty pub that is currently undergoing extensive refurbishment. The Pannier Market glimpsed at the top of the hill is, however, recognisable in both.

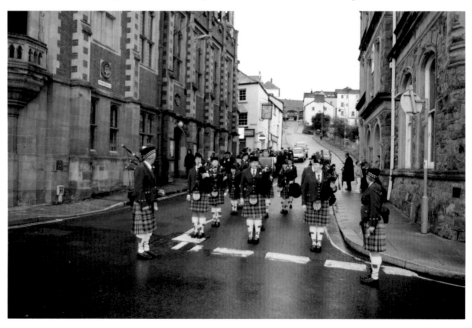

Union Street

Union Street is now just a narrow walkway through to the Bridge Street car park but in this 1953 photograph we can see how the residents had put up bunting to celebrate the Coronation. The end houses were, however, demolished along with the Methodist Chapel behind to form today's large car park – and who can say it is an improvement? At least the slate flagstones and cobbles still survive.

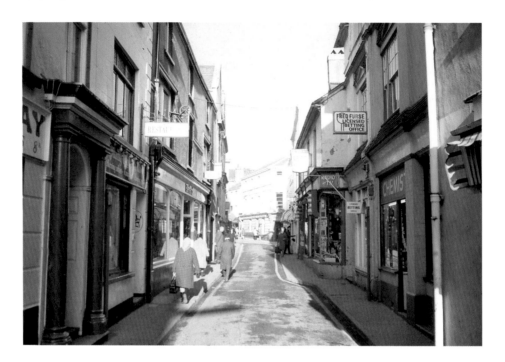

Allhalland Street

The rather shadowy photograph above dates from the late 1960s and shows Allhalland Street. It was once the main entrance to the town before the quay was extended from in front of Mr Chips to the end of the bridge. It takes its name from All Hallows Chapel that is thought to have stood at the western end of the bridge. Always narrow, the odd bulging section was the unfinished attempt by the town council to enlarge the road. The road is now pedestrianised for much of the day, hence the A-boards advertising local businesses standing in the road.

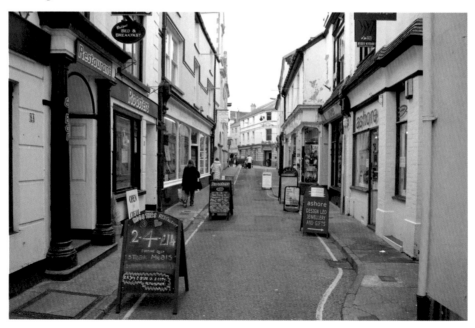

Methodist Chapel

In November 1892 the Methodists opened their new chapel colloquially known as 'the non-conformist cathedral of North Devon'. The 1960s photograph gives a good idea of its imposing size. Only twenty-one years later another Methodist Chapel was erected in High Street and eventually the congregations decided to use just this latter one and the Bridge Street one, amidst strong recriminations, was demolished to form a car park. The second photograph shows the same view after snow in 2012.

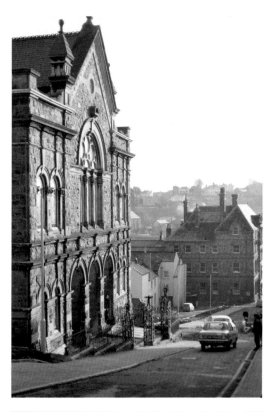

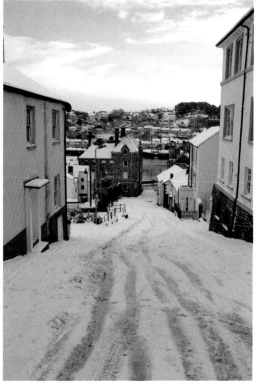

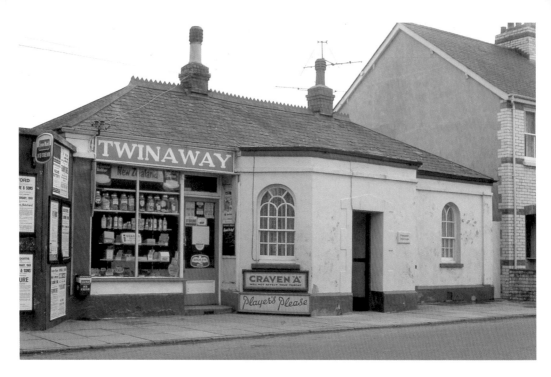

Toll House

In the eighteenth-century many roads in Britain became toll roads. The toll houses are easily identifiable by the extensions at their front with windows looking both ways along the road, whilst the toll gate would have extended across the road at this point. This one is half way up Clovelly Road and became a shop as shown here in a photograph from the late 1960s. Since then the remorseless rise of supermarkets has led to its closure and rebirth as a private house as shown in our 2012 photograph.

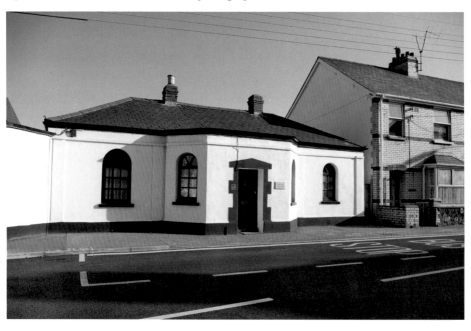

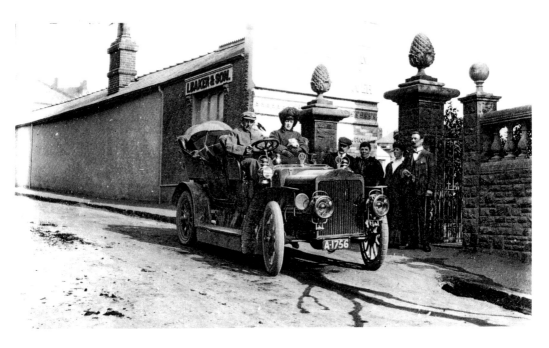

White's Steam Car

This wonderful looking vehicle was a White's steam car photographed on Torridge Hill before the First World War. The trail of water coming from the car is probably the condensed steam from the exhaust. The driver is Charles Stent and he is just setting off on his honeymoon with his new bride Winifred. The same scene today shows a car just passing what were the premises of I. Baker & Son builder's merchants.

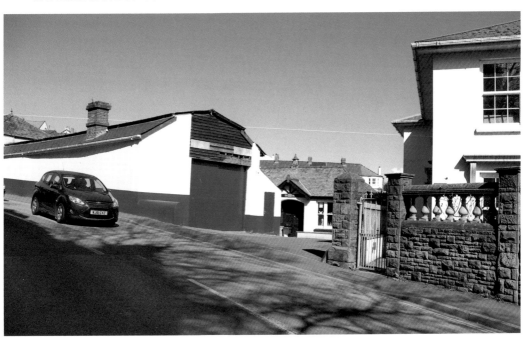

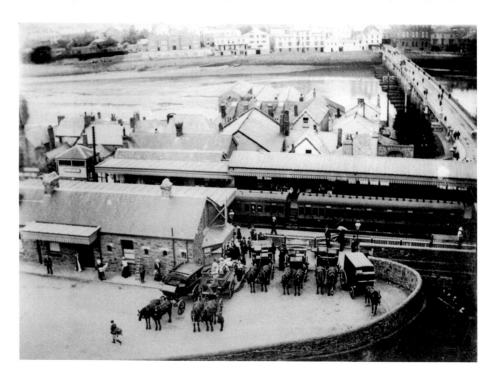

Bideford Station

The railway station taken from the hill above – a favourite vantage point for photographers over the years as is clear from the Edwardian example reproduced here. The collection of waggons testifies to the importance of the old rail system. The modern counterpart of this shot shows that the railway yard has become a car park and that Bideford's sobriquet of 'The Little White Town' (taken from Kingsley's *Westward Ho!*) is still applicable with many buildings facing the river painted in that colour.

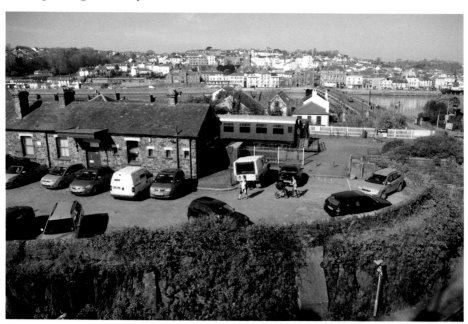

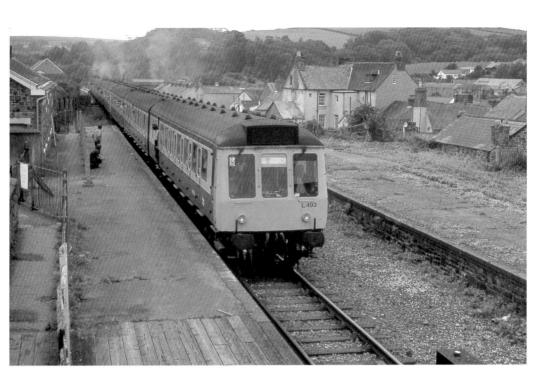

Signal Box

The absence of passengers on the station gives a clue as to why the railway disappeared from Bideford. I am unsure of the date but it was post 1968 when the buildings that used to stand on the overgrown tarmac were removed. In the second photograph we see the rebuilt signal box and vintage coach put in place by the local rail history group. The presence of many cyclists testifies to the popularity of the Tarka Trail and note the prone cyclist just crossing the old railway bridge.

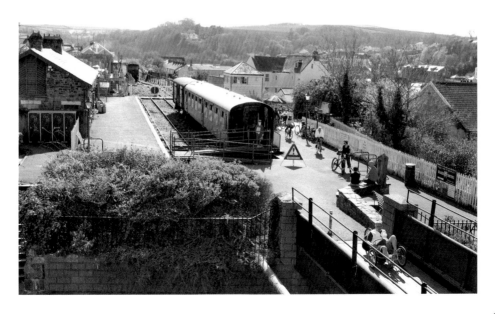

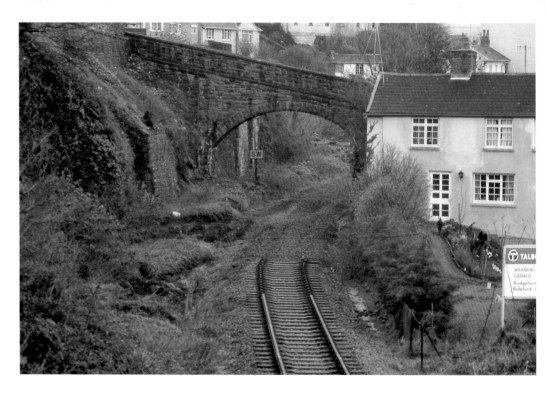

Railway I

The railway arrived in Bideford in 1855 and on its first day the line carried some 4,000 people to Bideford. As cars and lorries grew in numbers in the twentieth century so railway traffic shrunk with the final death knell being sounded by the Beeching Report of 1963 which recommended closure; the final train ran in January 1983. Our first photograph shows the line by Vinegar Hill as it was being removed soon after. The second shows the Tarka Trail that now occupies the old track.

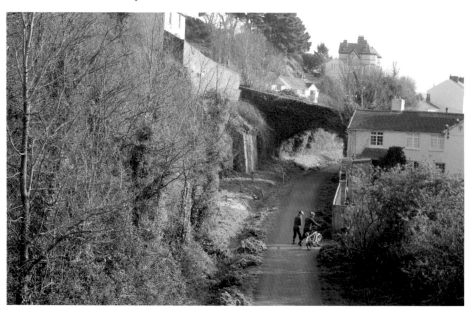

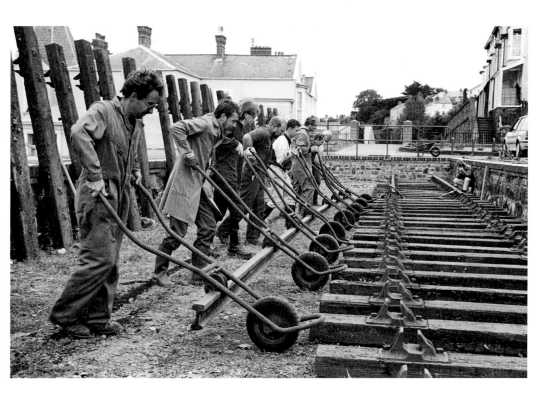

Railway II

The buildings on the 'town' side of the station were demolished in September 1968 but the one on the other side of the tracks still survives. The rails were removed later but there is a group of hugely committed railway buffs who have developed a small museum on the site, and even re-laid a section of the track as shown in this 1991 photograph. We managed to persuade some of this dedicated band to pose for us today, with the results shown here.

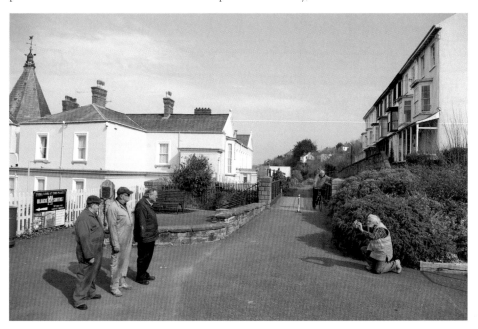

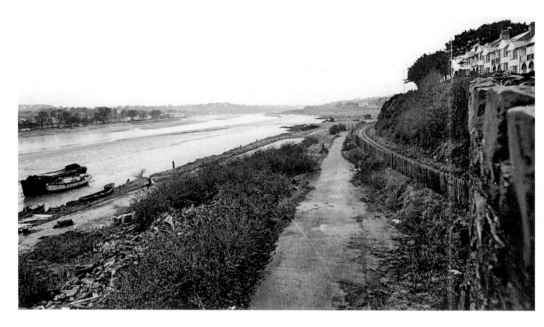

Railway III

The old railway goods yard at East-the-Water was closed in the mid-1960s and after protracted discussion Torridge District Council built the flats of the Ethelwynne Brown Close development. The first photograph shows the derelict area in December 1975 when the railway track was still present. The same view today shows the Tarka Trail which is the hugely successful cycle and pedestrian long distance path. The new high-level Torridge Bridge is in the background, built to this height to allow ocean going ships to travel below it.

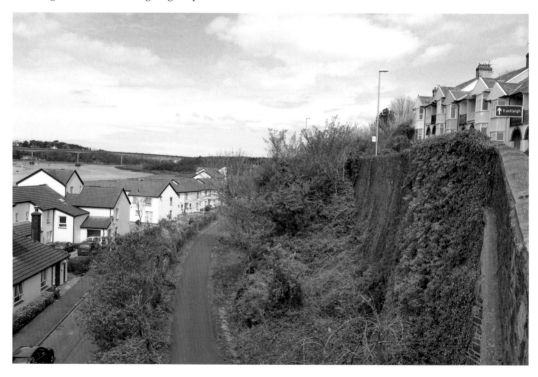

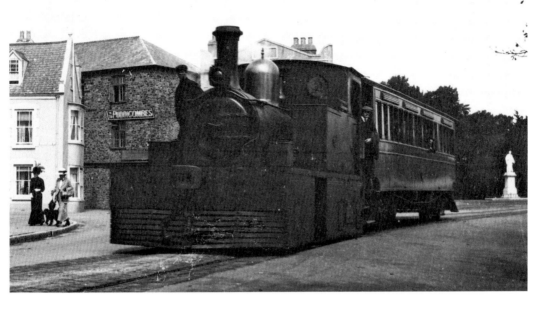

Bideford, Westward Ho! & Appledore Railway I

We couldn't publish a book like this without mentioning the Bideford, Westward Ho! & Appledore Railway. Opened in 1901 and closed in 1917 the little line came right along the quay into the heart of the town, as shown by this photograph. The same view today shows Quigley's on the left, the post office in the centre and Kingsley on his plinth to the right.

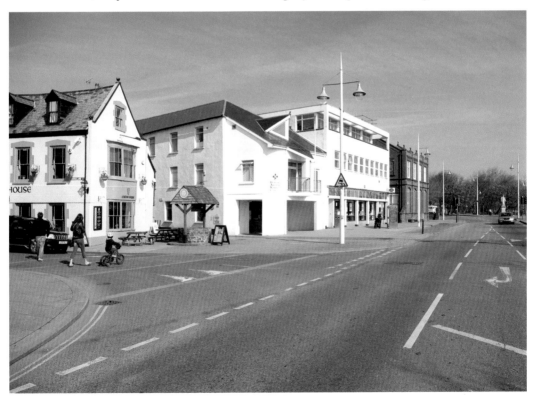

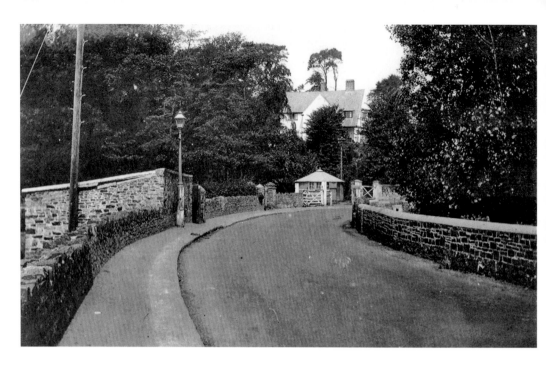

Bideford, Westward Ho! & Appledore Railway II

The Bideford, Westward Ho! & Appledore Railway line made its way from the quay as shown in the previous photograph via the Kenwith Valley to Westward Ho! The contractors built a level crossing where it crossed the Northam Causeway. The gates are shown in this photograph thought to be from the early 1920s after the rolling stock had disappeared. The modern view shows the entrance to the Kenwith Valley nature reserve roughly where the stone built shed used to stand.

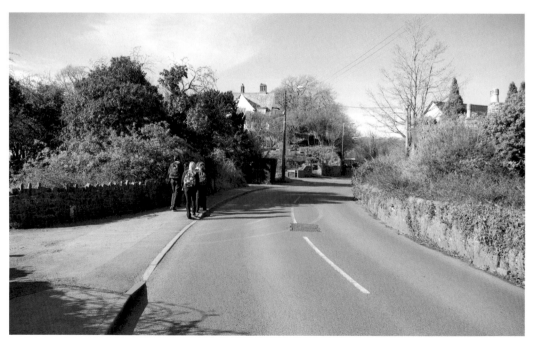

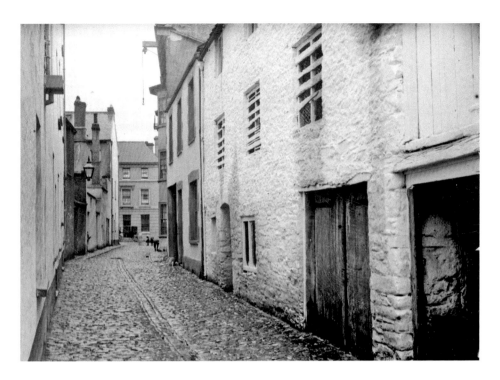

Queen Street

Queen Street once marked the edge of the quay which explains the presence of some grand buildings here. The first shot from the 1890s shows a cobbled road lined with warehouses, whilst the 2012 photograph displays a tarmac surface and the frontage of Heard's Garage, which began life as a coach building business. The bank building at the end is present in both.

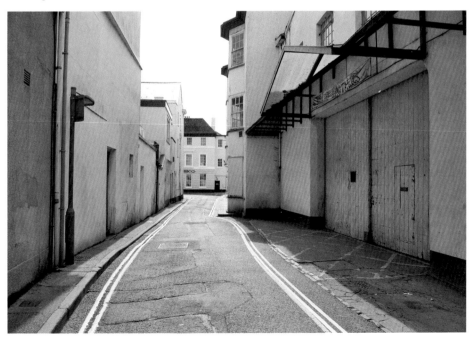

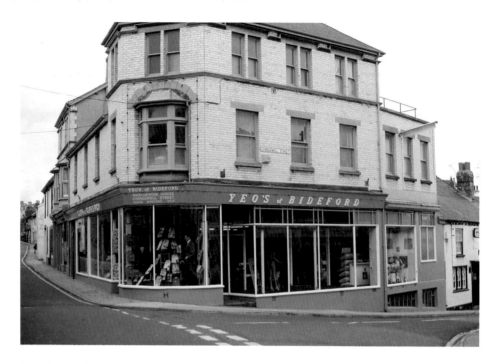

Manchester House

This venerable building was built for 'Yeo's of Bideford', a large if somewhat old-fashioned draper's shop on the corner of Chingswell Street and North Road. Known as 'Manchester House' it replaced an older building of the same name that once stood here. This building was recently refurbished and provides premises for a pet shop plus accommodation above. The owners have put up a new plaque bearing the name 'Manchester House' – a nice nod to historical continuity.

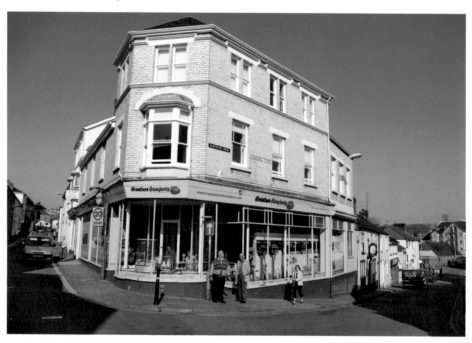

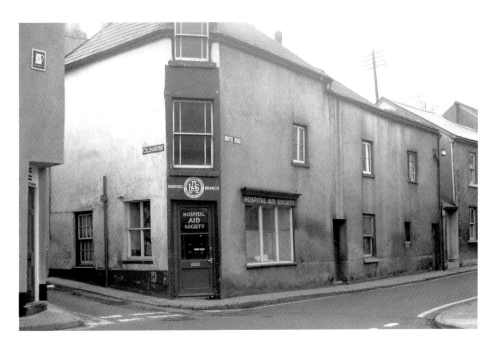

Junction of Coldharbour, Mill Street and North Road

This is the junction of Coldharbour, Mill Street and North Road. The first photograph dates from October 1973 when the building was being used as offices for the Hospital Aid Society. This was where locals paid a weekly sum in insurance just in case they fell ill and needed help. By 2012 the offices had long gone to be replaced with a dental surgery with new windows and burglar alarms though the old street signs are still in place.

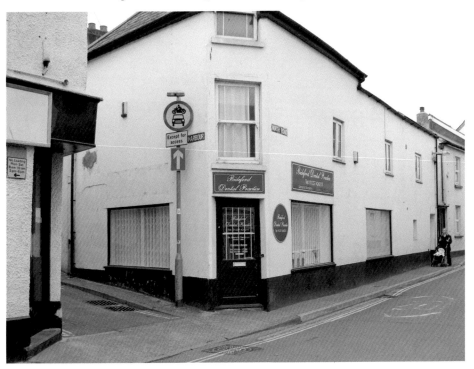

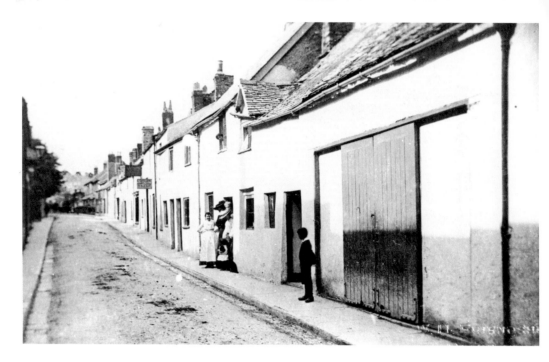

North Road

North Road was known until the mid-nineteenth century as Potter's Lane, owing to the presence of a large kiln here. The cottages once housed potters and ancillary workers and this was the main route to Northam via a causeway across Kenwith Valley. Today the pottery has gone (burnt down in 1893) and the Kingsley Road (opened in 1926) is now the main route to Northam.

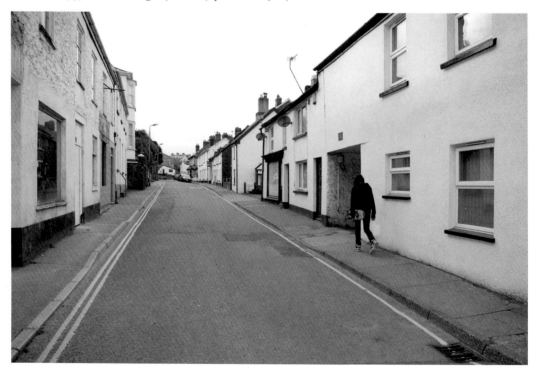

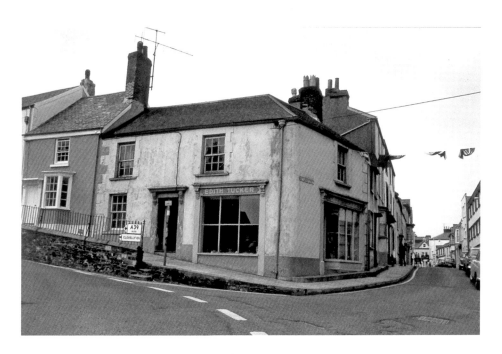

Junction of Meddon Street and Buttgarden

The junction of Meddon Street and Buttgarden is seen here in two shots some thirty-five years apart. The corner store of Edith Tucker is seen in the earlier one whilst in the second the shop fronts on both sides have gone, to be replaced by domestic windows designed to fit in with the existing building pattern. The houses belong to the Bridge Trust which is one of the biggest property owners in the town and which probably originated some 700 years ago when the bridge was built.

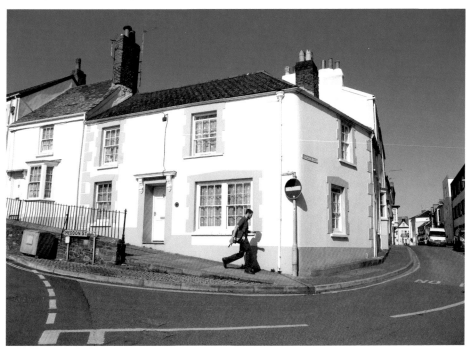

Corner of Meddon and Silver Street

This packed antique shop used to stand on the corner of Meddon and Silver Street up until the late 1970s. Run by the same family for many years it was an Aladdin's cave of a place. Following closure the shop was altered to produce some accommodation with the old plate glass windows being removed and replaced by a fairly bland frontage, including the ubiquitous satellite dish. Silver Street by the side has now become one-way though given its narrowness one wonders why it wasn't done many years ago.

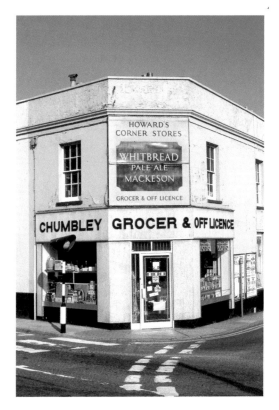

Junction of Old Town and Meddon Street
This tiny 'corner shop' used to be in premises at the junction of Old Town and Meddon Street. From the 1980s through to the 1990s it became solely an off-licence before succumbing to the all-conquering challenge of the supermarkets. New owners converted the shop to accommodation as shown in the second photograph. Note how the old zebra crossing which was dangerously close to the sharp road turning has been moved back some way.

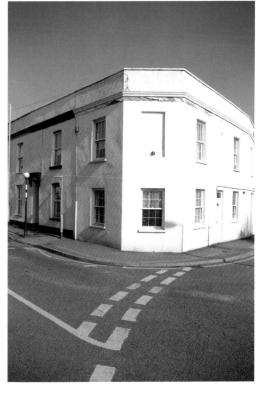

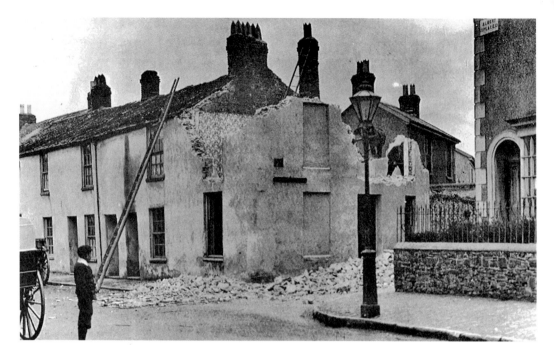

Milton Place

Milton Place is a small cul-de-sac leading off from Old Town. Its entrance today is narrow but in the past it was even more tortuous. With the growth of motor traffic it became obvious that it needed to be widened, which we see being carried out in this shot. Two men are seen knocking down the end house with sledgehammers and casually dropping the rubble into the street – no problems with health and safety then! The second photograph shows the scene today, crowded with cars.

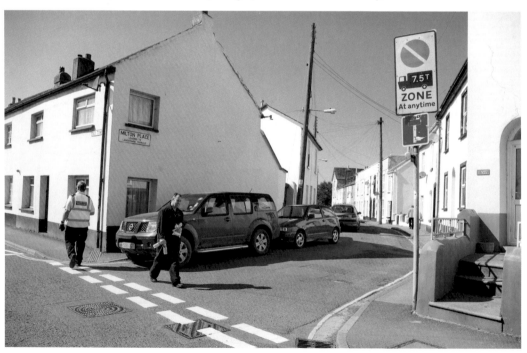

Market Place around 1905
Market Place is seen here
with some well-dressed
gentlemen casually
chatting in the road.
This part of town used
to be the trading hub
on Tuesdays and
Saturdays when
local farmers came
to Bideford to
conduct business
whilst their wives
would bring
hampers or panniers
of fresh produce to
sell in the Market
Hall. Today, the scene
is still recognisable apart
from the 'new' (1920s) art
deco white building in the
centre which was built for a
local building society and is now
a print shop.

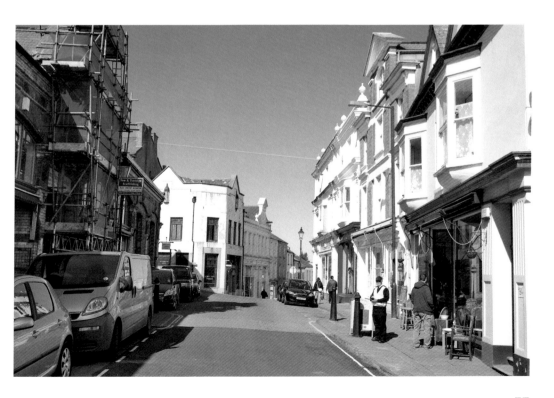

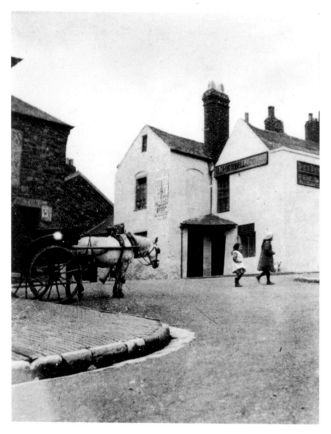

The Portobello Inn

The Portobello Inn is one of the last survivors of the numerous pubs that lined the Market Place, catering to the thirst and hunger of country dwellers who had travelled into town to buy and sell. The horse and cart have given way to the car and new doorways and windows have been inserted into the building, but the scene is still easily recognisable today.

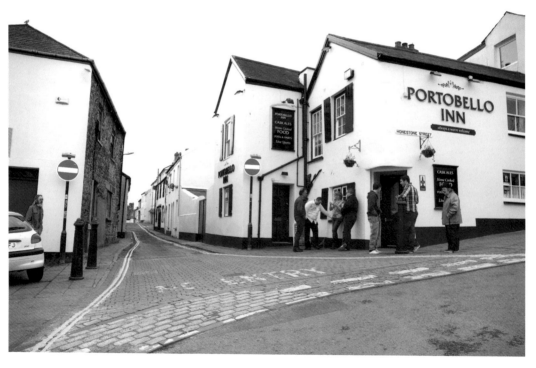

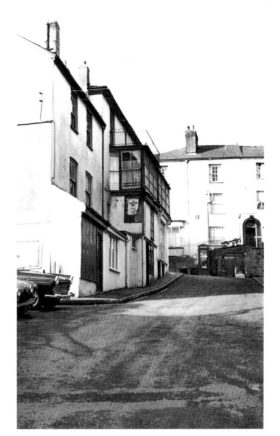

Pannier Market

One of the most changed views in this collection is shown here. Up until around 1980 the area next to the Pannier Market was filled with this old building. Its final use was as a Salvation Army building but it had been many things. During its demolition a very rare seventeenth-century wall mural was discovered in the basement which was rescued and is now on show in the Burton Art Gallery and Museum in town. The present-day scene shows a landscaped area with outdoor seating for the Market Café.

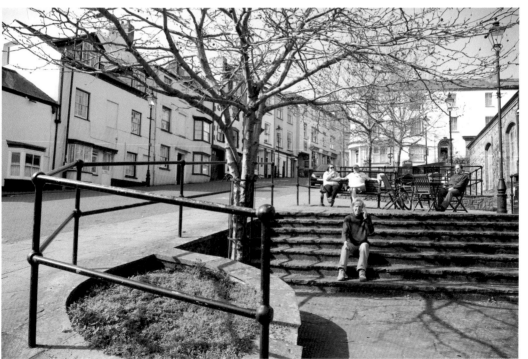

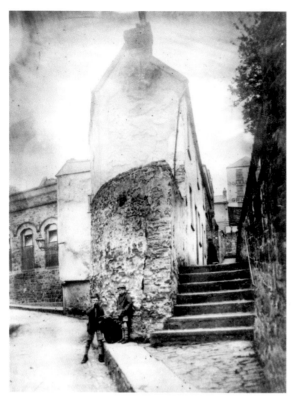

Lower Meddon Street
This original photograph from around 1900 isn't brilliant but it does show an odd little corner of Bideford in Lower Meddon Street. The building was constructed as the Church Institute and opened in 1913. Run for many years as a school (with a playground on the roof!) it was sold by the church to the Salvation Army and is now the headquarters of Wings, a local outreach charity.

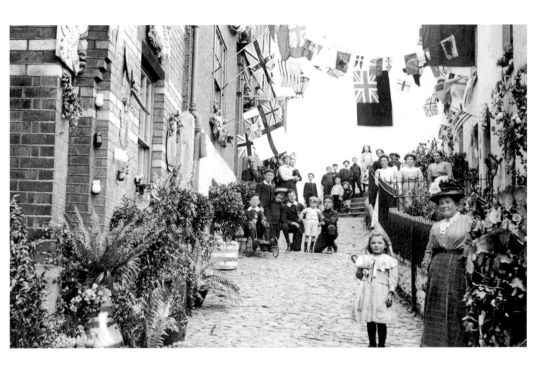

Tower Street
Tower Street is a quirky little backwater linking the church to the market place. Seen here in 1911 the flags are out to celebrate the coronation of George V. Note the proud lad in his early 'go-kart'. A century later the cobbles are still present, with added flagstones whilst the varied mixture of house styles is as attractive as it ever was.

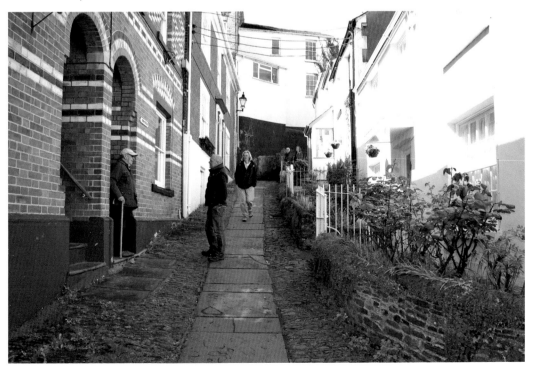

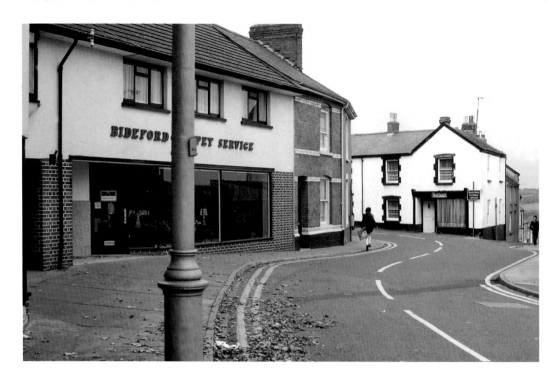

Coldharbour/Pitt Lane

Taken at the top of Coldharbour/Pitt Lane these two photographs, taken some forty years apart, may look superficially the same, but look again and you will see how the shop in the black and white house has disappeared, as has the lamppost in the foreground, and even the old-style television aerial. The yellow no-parking lines, however, are present in both.

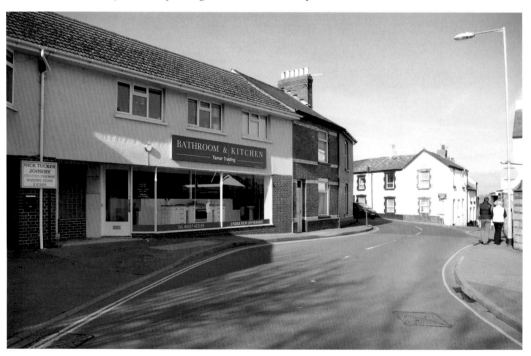

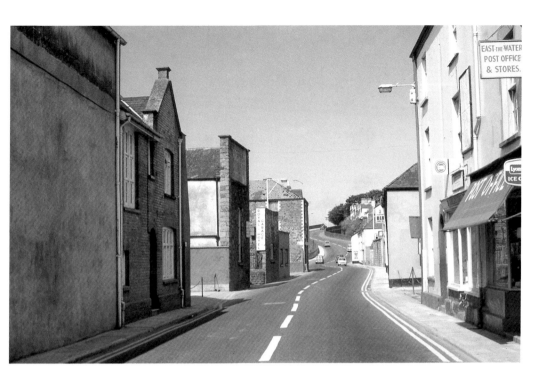

Barnstaple Street

Up until 1987 the Long Bridge was the lowest bridging point of the Torridge. The main access was via Barnstaple Street, which was widened in the 1920s to allow for motor traffic. It is shown here in a 1960s photograph when the large warehouses which used to line the East-the-Water bank were still in place. The second photograph shows the scene in 2012 with the old post office closed, a Chinese takeaway next door and the warehouses gone.

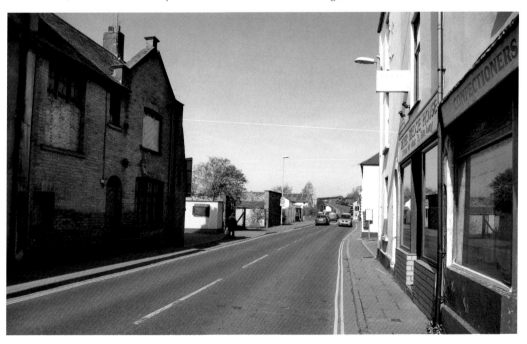

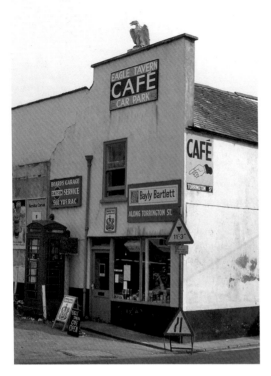

Torrington Street

These two photographs do not seem to show the same place and to an extent they do not. The 1960s photograph shows the Eagle Tavern Café which used to stand in Torrington Street opposite the Royal Hotel. It later became a dog grooming parlour and then a private house before being demolished; the site was later incorporated into the hotel's car park.

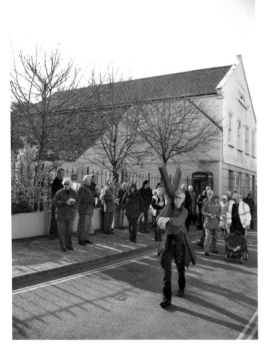

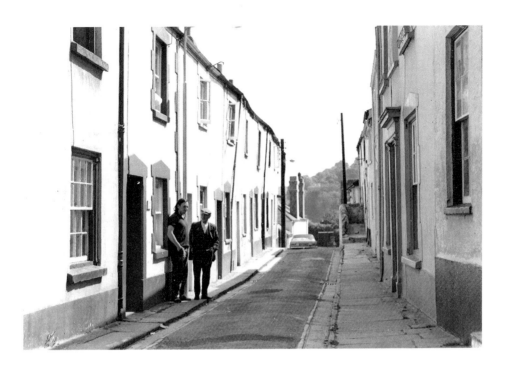

Bull Hill

Bull Hill is said to owe its name to the barbaric custom of setting dogs on to a tethered bull to tenderise its flesh. In the 1970s the houses on half of Bull Hill were demolished – the ones to the left in the 1975 photograph above – and later rebuilt in matching style. The two people in the photograph are 'Grampy' Phillips and his son Tony, who lived at the 'town' end of the street. Our modern photograph shows Tony recreating the scene from thirty-seven years before.

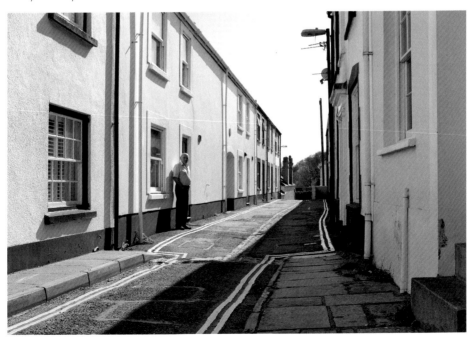

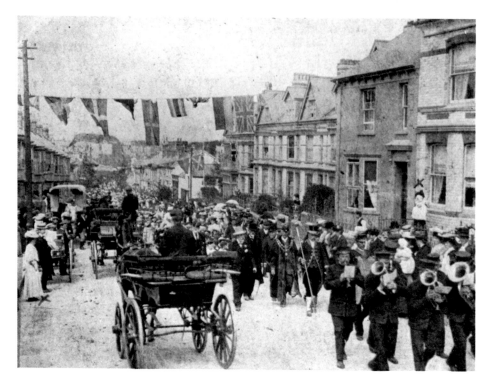

Clovelly Road

Clovelly Road is a handsome street with a mix of large and small houses. In May 1907 the Devon County Show came to Bideford, being held at the top of the town, and here we see the Mayor, Beadle and councillors processing up to the site behind the town band. Today's view is very similar though cars have obviously replaced horse-drawn conveyances, and nobody is walking in the road.

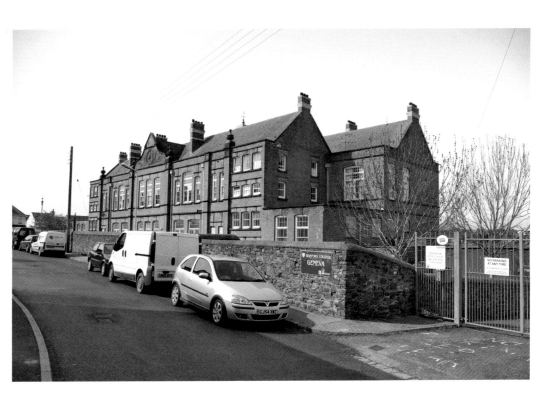

Geneva Place

Generations of Bideford children have attended the school in Geneva Place but it has now closed and has been replaced by a sumptuous new school just across the road. The original was built in 1903 and here we see it under construction – with a modern view for comparison. Little has changed apart from the ubiquitous cars that are ever present.

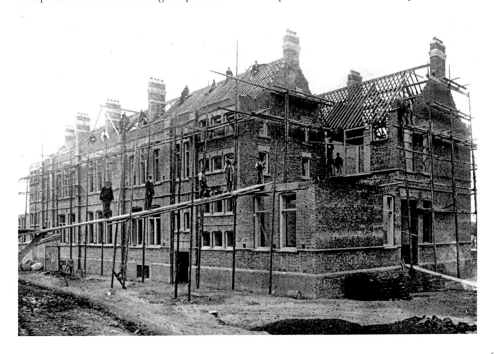

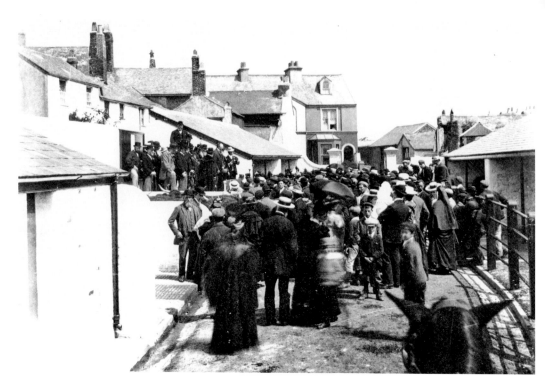

Cattle Market

For many years animals were brought to Bideford and sold in the streets surrounding the Market. In 1898 the council opened a new custom-built cattle and sheep market in Honestone Street, and here we have the opening ceremony by the mayor of the day. In 1960 the market moved again down to Bank End and has now closed. The site of the earlier one now houses a small industrial development and is seen here looking out to Honestone Street.

New Street

New Street was a tightly packed small road with a great community spirit – until the houses were demolished in the post-war 'slum clearances'. After standing empty for many years, one side of the street was rebuilt with houses along with a new development initiated by the Bridge Trust next door in Lower Gunstone.

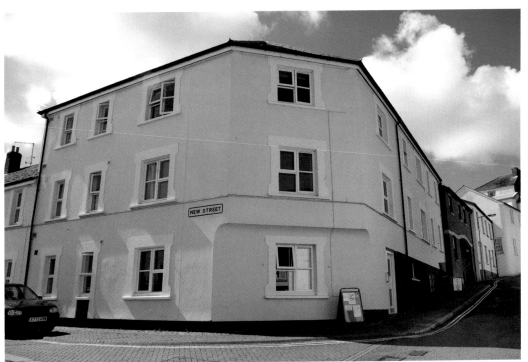

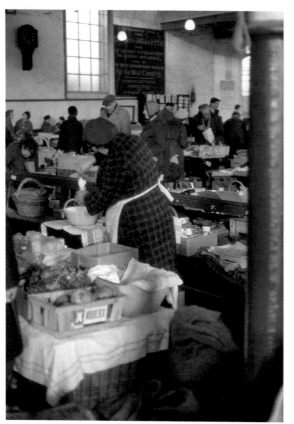

Bideford Pannier Market Hall
Bideford Pannier Market Hall dates from 1883 when the town council rebuilt the old run-down structure. This provided a covered hall for local people to sell produce and other items. The first photograph from 1969 shows one of the stallholders ladling clotted cream into a jam jar. The second shot shows a boxing ring erected for a series of bouts on one night in March 2012. The old-style panniers have now gone but the market traders still attend on Tuesdays and Saturdays throughout the year.

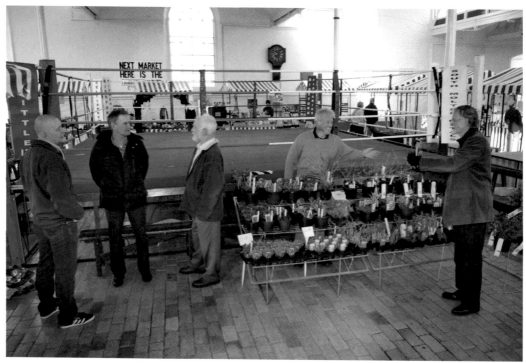

Sports Ground

The Sports Ground used to be an area of marshland before being drained and laid out in the 1920s as a venue for athletics meetings, town pageants, rugby and football. This photograph taken in July 1966 shows a small band of willing helpers putting the new floodlights together prior to their erection. In both photographs is the large building housing Heard's Coaches, which used to be one of the two engine-sheds of the Bideford, Westward Ho! & Appledore Railway.

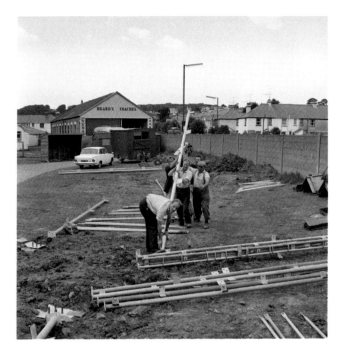

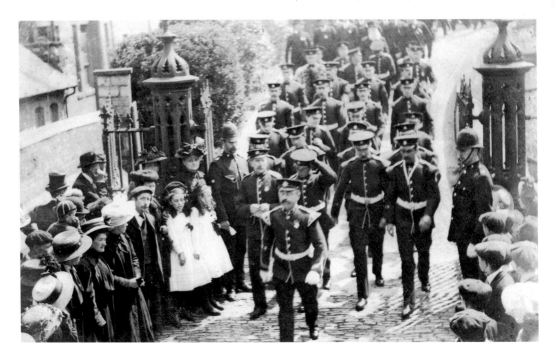

4th Volunteer Battalion of the Devon Regiment

The men of the 4th Volunteer Battalion of the Devon Regiment shown here were the descendants of the Bideford Rifle Volunteers first formed in 1859 to repel a threatened invasion by the French. They are seen here marching through the gates of St Mary's after a church service. Our second photograph shows the Bideford Town Band similarly marching through the now rather less ornate gateway at St Mary's after playing at a civic service.

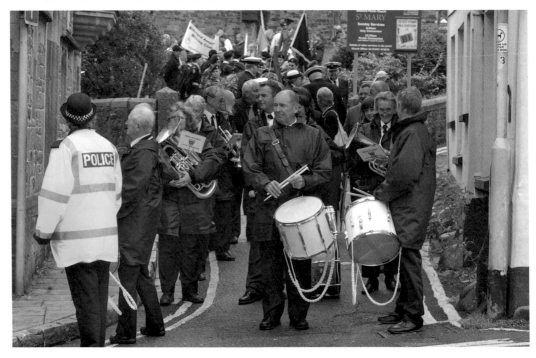

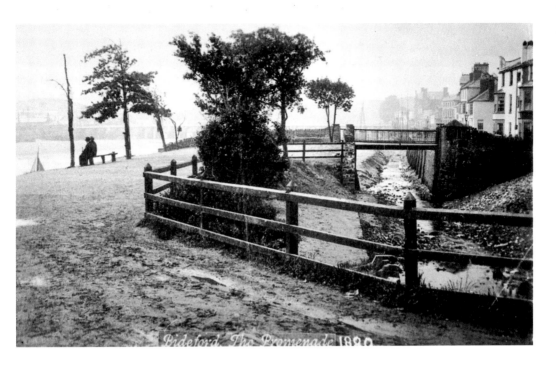

The Promenade

This was the Kingsley Statue end of the quay before 1900. The small bridge crossed over the Pill stream in front of today's Art School, which was filled in to allow construction of the Bideford–Westward Ho! railway. Our modern shot is very different and one would be hard pressed to know a stream ever existed here let along a bridge.

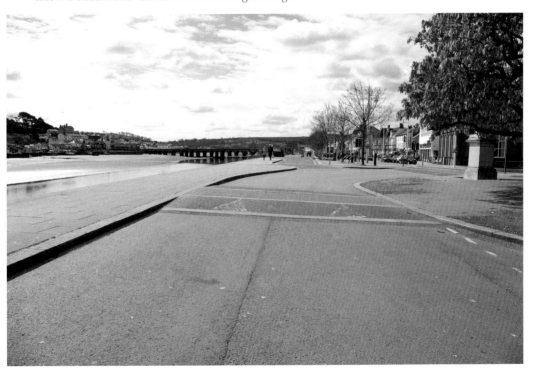

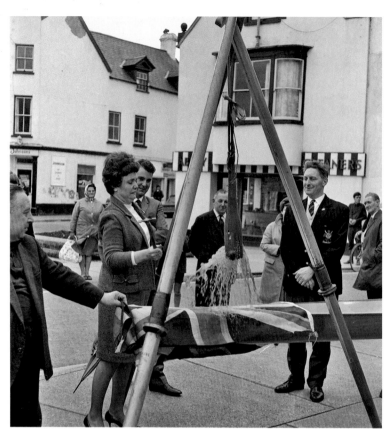

Rowing and Bideford

The christening of new boats by Bideford's two rowing clubs is always recorded. Here from 1967 we see Diane Inch breaking a bottle of cider over the new *Caroline* gig in front of the Red's clubhouse on the quay. Our second shot was taken by this book's photographer Graham Hobbs and shows the book's writer Peter Christie (fourth from left) in his role of chairman of the Bridge Trust naming a new gig in 2012.

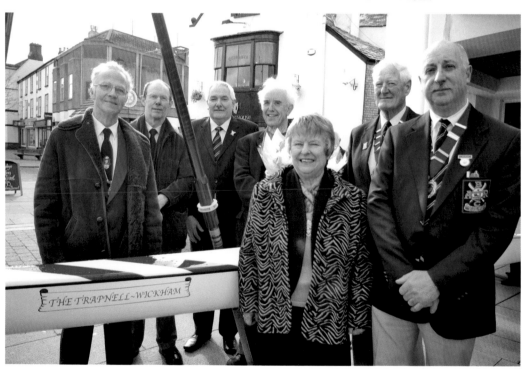

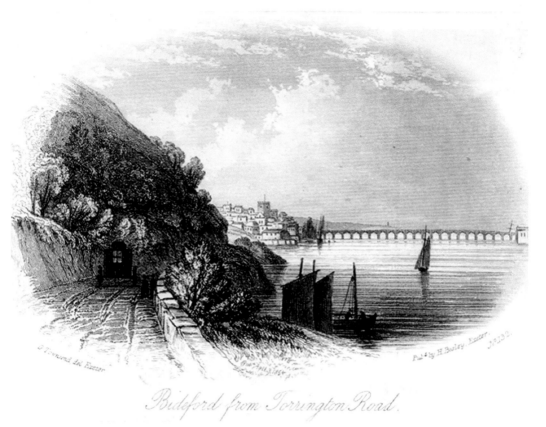

Bideford from Torrington Road.

An 1854 print of Bideford and the bridge.

Acknowledgements

The old photographs used in this book come from a variety of sources. We would like to say thank you for making them available. Owners retain the copyright:

S. Ackland, J. Baker, Bideford Library, A. Blamey, G. Braddick, R. Cann, O. Chope, D. Gale, T. Hatton, K. Hearn, L. Lane, R. Lloyd, R. Morris, *North Devon Journal*, North Devon Museum Trust, and D. Warmington.